IMAGES
of America

SACRAMENTO'S
MIDTOWN

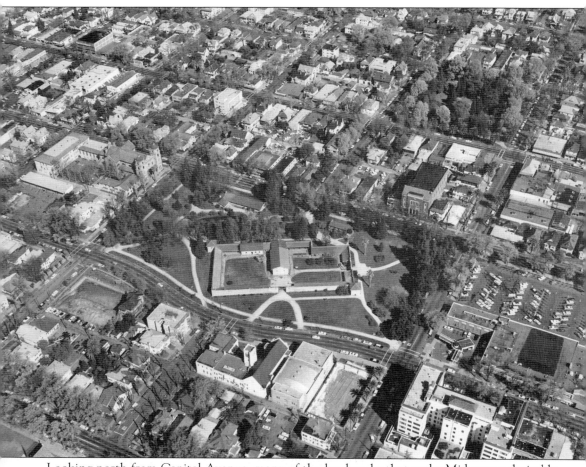

Looking north from Capitol Avenue, many of the landmarks that make Midtown a desirable place to live, work, and play are visible in this 1961 photograph. Showcasing Sutter's Fort and its park setting is the broad sweeping curve of L Street, which was realigned when the fort was restored. No other lettered or numbered street in the old city grid has this feature. Immediately surrounding the fort are the churches, schools, clubs, and businesses that help define Midtown. On the west is the St. Francis Church and School at Twenty-sixth and K Streets. North of the park is the Eastern Star Temple on K Street near Twenty-eighth Street, the meeting place of Sacramento society mavens. Along the eastern side of the park on Twenty-eighth Street is Raley's Grocery in the Fort Sutter Shopping Center and the Sutter Hospital campus. Facing the front of the fort on L Street are the Scottish Rite Temple remains, the Tuesday Clubhouse, the Pioneer Congregation Church, and an apartment building. Spreading out from the fort is a complex mix of single-family homes, apartments, businesses, parks, and schools. (Courtesy *Sacramento Bee* Collection.)

ON THE COVER: Snowstorms in Sacramento are relatively uncommon. This storm in late January 1922 dropped several inches of snow on the Sacramento Valley, including five inches in Orangevale and nearly two inches at Sutter's Fort. The *Sacramento Bee* records that the "mantle of white" produced spontaneous snowball fights across town, even prompting theatergoers to abandon their movie watching to participate. (Courtesy Sacramento Valley Photographic Survey Collection.)

IMAGES
of America

SACRAMENTO'S
MIDTOWN

Sacramento Archives and Museum Collection Center
and the Historic Old Sacramento Foundation

ARCADIA
PUBLISHING

ISBN 978-0-7385-4656-8

Published by Arcadia Publishing
Charleston SC, Chicago IL, Portsmouth NH, San Francisco CA

Printed in the United States of America

Library of Congress Catalog Card Number: 2006924390

For all general information contact Arcadia Publishing at:
Telephone 843-853-2070
Fax 843-853-0044
E-mail sales@arcadiapublishing.com
For customer service and orders:
Toll-Free 1-888-313-2665

Visit us on the Internet at www.arcadiapublishing.com

This book is dedicated to all of SAMCC's volunteers and interns who have served the archives so diligently and thoughtfully over the years.

CONTENTS

ACKNOWLEDGMENTS

The authors would like to thank a number of people who assisted us with the preparation of this book. Our thanks go to the people at Arcadia Publishing for their help and guidance, especially our editor, John T. Poultney. We particularly would like to thank Steve Huffman, executive director of the Historic Old Sacramento Foundation, and the Sacramento History Foundation for their encouragement of this effort. Invaluable to this endeavor was our manager, Jim Henley; without his support, this project never would have happened.

To keep us true and correct in all our facts and syntax for this book, we owe a debt of gratitude to our stalwart volunteers, Bill Gaylord, Steve Melvin, and Kevin Morse. We also thank all our volunteers at the Sacramento Archives and Museum Collection Center (SAMCC); we could not do our work without their help.

We have drawn on our extensive photographic collections at SAMCC in preparation for this book. We would especially like to thank the photographers who are the ultimate source of the over five million images in the collections: Lloyd Fergus, the Frederick-Burkett Studios, Eugene Hepting, David Joslyn, the McCurry Company, Ernest Myers, Ralph Shaw, Levi Vandercook, the many *Sacramento Bee* photographers, and all the others too numerous to mention. We also send our appreciation to the families of these photographers, who were often the actual donors of the images.

Our thanks also go to the collectors of these images: the California State Library, Frank Christy, Jim Henley, Eugene Hepting, the Howe family, Bob McCabe, Eleanor McClatchy, Ernest Myers, the Sacramento Metropolitan Chamber of Commerce, and the Sacramento Public Library. Your appreciation of the importance of our history makes all of this possible.

INTRODUCTION

Sacramento's Midtown, the focus of this book, is traditionally defined as Capitol Park's eastern boundary at Fifteenth Street east through Alhambra Boulevard and from the north at the American River to the south at Broadway.

By the 1870s, Sacramento's downtown was bulging at the seams and natural expansion was to the east. Even though the city grid laid out in 1849 extended all the way to Thirty-first Street, growth into those reaches was slow until the 1870s. With the development of transportation eastward, people began building homes, churches, schools, and businesses along the lettered streets and particularly the J, K, L, and M Streets corridors that surround Sutter's Fort. The R Street corridor did evolve in the 1850s along the railroad right-of-way, but mostly manufacturing rose in that area.

Readers will notice that the book is centered around the corridors found within Midtown. Development in the area centered first on the lettered streets and then moved to the numbered streets, similar to downtown's evolution. The book begins with Sutter's Fort, as the fort was the precursor to the founding of the city. Then in a more orderly fashion, the discussion proceeds with neighborhoods on the north from C Street down to I Street, which includes the Boulevard Park and New Era districts. Next is the story of the business corridors found within Midtown, particularly Alhambra Boulevard and J and K Streets. Then it continues to the capitol corridor of L, M, and N Streets, showcasing the structures along this corridor. The industrial and manufacturing corridor along R Street is covered in its own chapter. Concluding the neighborhood sections is O Street to Broadway and its environs. A thematic chapter on transportation and the changing nature of getting around Midtown then follows. The book ends with a chapter on the culture and society of Midtown: its schools, churches, and a discussion of the important contribution of Memorial Auditorium.

The old saying "a picture is worth a thousand words" rings true for this book. The criteria used for choosing the photographs boiled down to those that illustrated the dynamic life in Sacramento as it changed over time. More than just pictures of static buildings, street scenes, or portraits, images that depicted action and moved the story along were selected. It was also important to choose images that had not been used in the many previous publications about Sacramento's history. However some photographs were so superior or others captured a scene so perfectly, no real alternatives were suitable or available. All the images used for the book came from SAMCC's collections. Generally the chapters were organized geographically, moving up the streets; however thematic elements or layout factors may have occasionally altered this guideline.

The Sacramento Archives and Museum Collection Center (SAMCC) grew out of the early Landmarks Commission. This organization was responsible for the core collections that developed into what the archives is today. The Landmarks Commission evolved into the Sacramento Museum and History Commission, responsible for developing a museum for Sacramento. As a result, collections began to grow, with the largest expansion taking place between 1977 and 1983.

During that time, the Sacramento Museum and History Commission became an official division of Sacramento city government, creating the official archives.

The Historic Old Sacramento Foundation's (HOSF) mission is to conduct interpretive historical programs in order to improve Old Sacramento's value as a historic and cultural asset. HOSF conducts regular walking tours of the district with the help of a dedicated corps of volunteers. They advocate a major gold-rush museum and attraction, increasing the number of historic events, and improving the marketing of Old Sacramento as a destination and a place to learn history.

One

Sutter's Fort
The Beginning of It All
By Dylan McDonald

When John Sutter stepped off the schooner *Isabella* in 1839 and onto the bank of the American River, foremost on his mind was finding the ideal spot to begin building his colony. Key to his venture was selecting the right location in an area dominated by two rivers and numerous wetlands. The prevalence of water not only demanded high ground, so did the settlement's remoteness from other western outposts—literally an island in a sea of a native populous. While Sutter's Fort was built in a defensive position, its back to the river with two bastions and numerous cannons, the location was also chosen to provide its owner with a central location to oversee his land. Making use of the transportation corridors and being close to the confluence of the American and Sacramento Rivers, Sutter was soon controlling the area's commercial and agricultural trade.

From this spot, Sutter oversaw his would-be empire despite the political struggles that enveloped California in the 1840s. Dependent upon native labor, eager to see his lands settled, and plagued by growing debt, Sutter saw his investment and dreams overrun by the masses struck by gold fever. By the end of 1849, just 10 years after its enthusiastic founding, the fort was sold, and Sutter retired to Hock Farm. Yet it is this spot, today known as Twenty-eighth and L Streets, which gave rise to the great city of Sacramento and, arguably, the great state of California.

Sutter's Fort is one of Sacramento's most-visited tourist destinations and a source of pride for Midtown residents. However it might never have become such if not for the foresight of determined preservationists. As the fort lost its importance during the heyday of the gold rush, it fell victim to scavengers and the elements. Soon all that remained of the structure was the central building. Saved through the efforts of the Native Sons of the Golden West and the state legislature in the 1890s, today it is part of the state's park system. Offering visitors the sights, sounds, and smells of 1840s California via living history programs, exhibits, and demonstrations, the fort truly is the beginning of any visit to Sacramento.

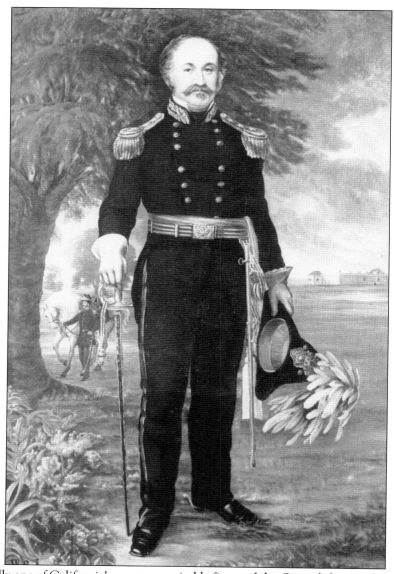

Undoubtedly one of California's most recognizable figures, John Sutter left an enduring mark on the state's history, government, geography, tourism, and ethnic relations. Born Johann Augustus Suter in February 1803 to Swiss parents living in Kandern, Baden (Germany), Sutter attended military school and then apprenticed at a bookbindery in Basle. Married at age 23 to Annette Dübeld, the young Sutter tried his hand unsuccessfully in various commercial ventures. With the strain of creditors and the responsibility to provide for a wife and four children, he looked toward the New World to improve his prospects. Leaving his family in the care of a brother, the eager traveler made his way to New York City in 1834. Over the course of the next few years, Sutter made his way west, stopping in St. Louis; Santa Fe; Fort Vancouver; Honolulu; Sitka, Alaska; Monterey; and finally to Yerba Buena (San Francisco), where the epic chapter began. This 1855 romantic painting, *Portrait of General John A. Sutter* by William Smith Jewett, was commissioned by the state and shows an aged Sutter regaled in his California militia uniform. (Courtesy Eleanor McClatchy Collection.)

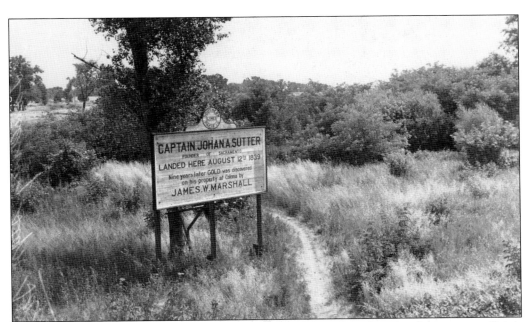

Having arrived in Mexican California, Sutter obtained permission from local governing officials to establish a colony in the interior. He soon chartered the schooner *Isabella* and two other boats, each loaded with provisions, tools, seeds, and guns, to journey up the Sacramento River. Leaving in early August 1839, the small fleet turned east at the mouth of the American River and landed near today's Twenty-eighth and C Streets on August 12. (Courtesy Eleanor McClatchy Collection.)

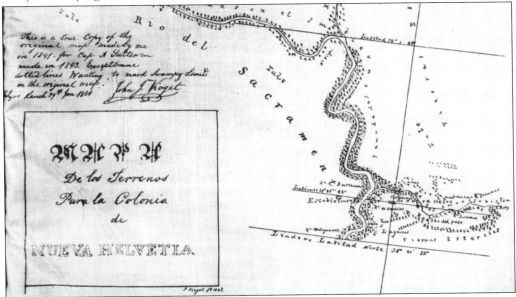

Sutter chose to build his colony about a mile from the landing site, on higher ground. With 14 other settlers, and soon with native help, Sutter began building his settlement, Nueva Helvetia (New Switzerland). He became a Mexican citizen in 1840 to secure title to the land, which was granted on June 18, 1841. This map by Jean Jacques Vioget shows a portion of the 11 leagues granted by Gov. Juan B. Alverado. (Courtesy Eleanor McClatchy Collection.)

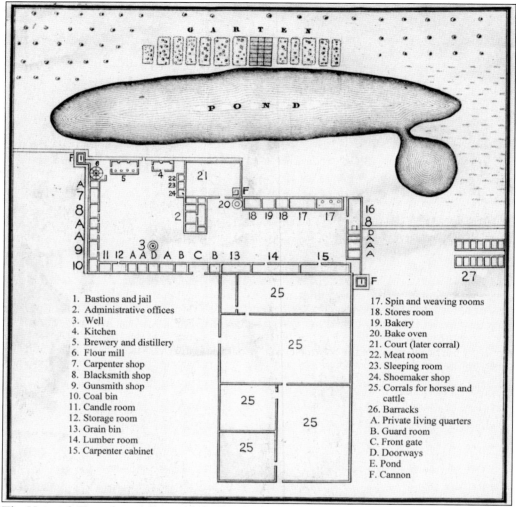

1. Bastions and jail
2. Administrative offices
3. Well
4. Kitchen
5. Brewery and distillery
6. Flour mill
7. Carpenter shop
8. Blacksmith shop
9. Gunsmith shop
10. Coal bin
11. Candle room
12. Storage room
13. Grain bin
14. Lumber room
15. Carpenter cabinet

17. Spin and weaving rooms
18. Stores room
19. Bakery
20. Bake oven
21. Court (later corral)
22. Meat room
23. Sleeping room
24. Shoemaker shop
25. Corrals for horses and cattle
26. Barracks
A. Private living quarters
B. Guard room
C. Front gate
D. Doorways
E. Pond
F. Cannon

The Heinrich Kunzel map, first published in Germany in 1848 to promote German immigration to California, shows the footprint of Sutter's Fort. Finished in 1844, the enclosure had two-and-a-half-foot thick adobe walls that were between 15 and 18 feet high. The fort had two bastions armed with cannons Sutter purchased in Hawaii and from Fort Ross. The map's key indicates what the rooms were thought to have been used for originally, although over the course of time their uses changed. The fort could accommodate around 300 persons during the day, although less than 50 actually called it home. When making a visit to the fort today, the only remaining structure from the original fort is the central building, indicated on the map by the No. 2. From this building, Sutter oversaw his nearly 48,000 acres, with its large native population and a growing number of settlers, in addition to his thousands of cattle, crops, tannery, fort, and later, a famous mill. This map was revised for publication in the *Sacramento Bee*, and it was translated from its original German to English. (Courtesy *Sacramento Bee* Collection.)

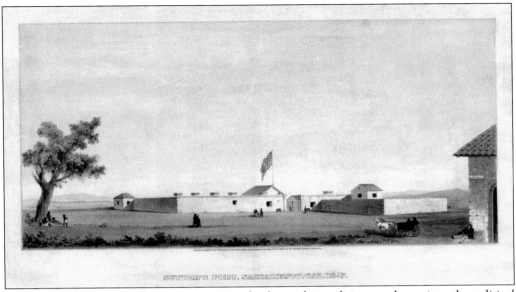

Due to its prominence and strategic location, the fort and its militia were drawn into the political turmoil between the United States and Mexico over California throughout the 1840s. Yet during this time, Sutter received numerous visitors and weary travelers, including John C. Fremont and Kit Carson. In the winter of 1846–1847, he sent rescue parties to assist members of the ill-fated Donner Party trapped by the heavy snows of the Sierra Nevada. (Courtesy Catherine MacMillan Collection.)

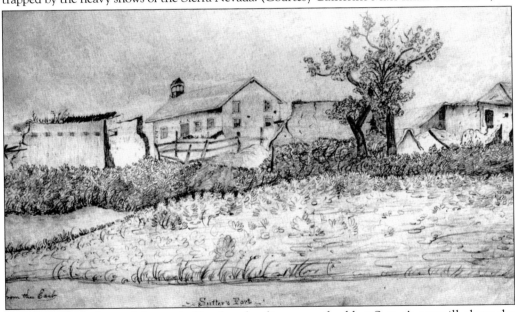

Life at the fort changed dramatically after the discovery of gold at Sutter's sawmill along the American River at Coloma. James Marshall brought word in January 1848 of the find, and soon thousands of gold seekers overran Sutter's property, destroying crops and stealing livestock. Commerce moved to the Sacramento River, where the forty-niners disembarked for the gold fields, spawning the new city of Sacramento and cutting off the fort, which was sold by Sutter and thereafter fell into disrepair. (Courtesy *Sacramento Bee* Collection.)

John A. Sutter Jr. arrived in 1848 and took over his father's affairs, canceling his debts and founding the city of Sacramento. Sutter himself retired to Hock Farm, along the Feather River, with his now reunited family. While Sutter did serve on California's constitutional delegation, he spent the rest of his life trying to gain governmental compensation for his lost property. This c. 1880 photograph shows only the fort's central building left standing. (Courtesy California State Library Collection.)

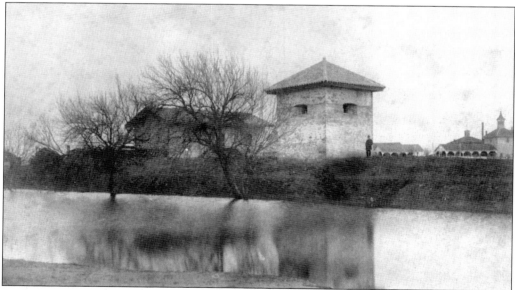

By the late 1800s, there was a growing consensus that Sutter's Fort needed to be preserved, and in 1888, the Native Sons of the Golden West (NSGW), a fraternal organization of native-born Californians, began raising funds. By 1890, they had raised the $20,000 needed to purchase the property. This photograph, taken c. 1891 from about Twenty-seventh and K Streets, looks across the slough and shows the beginnings of restoration. (Courtesy Sacramento Valley Photographic Survey Collection.)

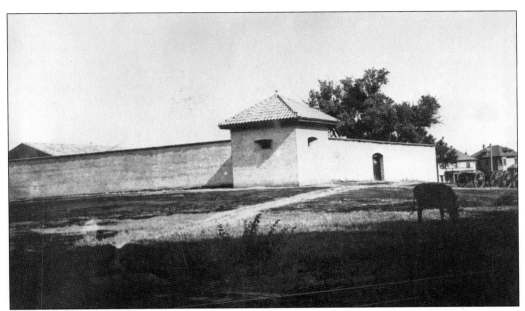

The fort's various owners had knocked down the fort's walls and buildings, often to be scavenged for building materials, or left the property to the elements. The restoration project was a large undertaking. Funds were appropriated by the legislature to begin restoration after the NSGW donated the site to the state. This *c.* 1893 image is of the recently completed southeast bastion and east gate. (Courtesy Ralph Shaw Collection.)

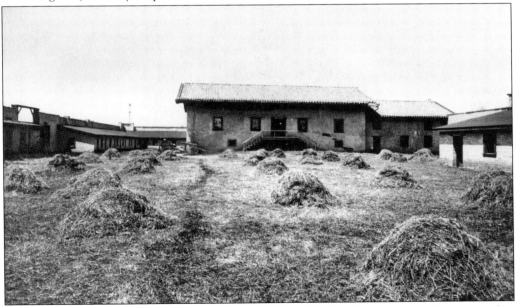

Using the best archeological techniques known at the time, the fort was restored to a state that nearly matched the original structure. The recreated fort, with its enclosed walls, bastions, and buildings, offers visitors an excellent insight into life in 1840s California. This *c.* 1900 image shows the fort's interior with a recently cut crop of drying hay in front of the central building. (Courtesy Eleanor McClatchy Collection.)

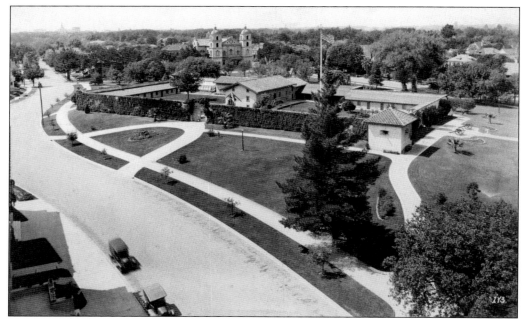

This *c.* 1923 view to the northwest, with the Mission-style St. Francis Church in the background, shows the park setting of the reconstructed fort. While the neatly manicured landscaping and wisteria-covered walls helped the structure fit nicely into the residential neighborhood, the 1840s fort would never have looked as such. Balancing historical interpretation versus the realities of a modern tourism site comes with trade-offs. (Courtesy City of Sacramento Collection.)

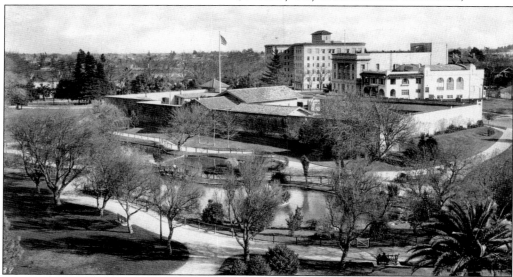

Overlooking the park to the southeast, *c.* 1923, were three prominent buildings—Sutter General Hospital, the Scottish Rite Temple, and the Tuesday Clubhouse. The growth of Midtown's residential and commercial structures has presented a challenge to the park and its full rehabilitation. Remnants of the fort and its outbuildings now lie under nearby streets and adjacent structures. The ponds in the foreground are all that remain of the onetime slough. (Courtesy Vera L. Whybark Collection.)

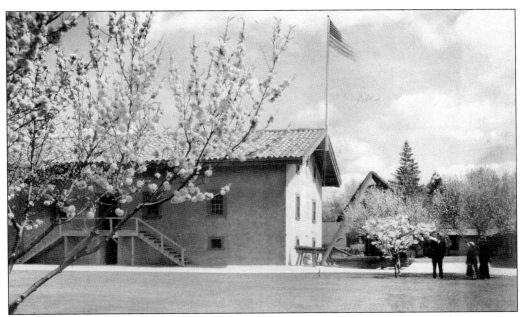

A c. 1930 photograph of the fort's interior captures the central building, the only remaining structure from the time of General Sutter. The rehabilitated building includes hand-hewn oak beams and thick adobe walls. Since its construction, the building has served many purposes—Sutter's private office, a hospital, a private residence, and a refuge for victims of the 1906 San Francisco earthquake. Today a portion of the building houses the Sutter's Fort Archives. (Courtesy Sacramento Metropolitan Chamber of Commerce Collection.)

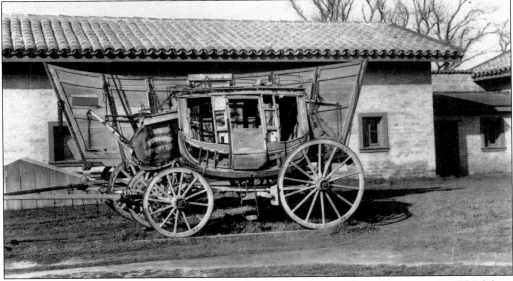

Serving as a link to the past, the fort began the move to being a formal museum in 1924. Many of the items at the fort were reflective of the gold-rush era, including these wagons that were longtime fixtures on the fort grounds. At one time, the Concord stagecoach took travelers to the region's southern mines. The large California Freight wagon was used to haul goods and supplies. (Courtesy Vandercook Collection.)

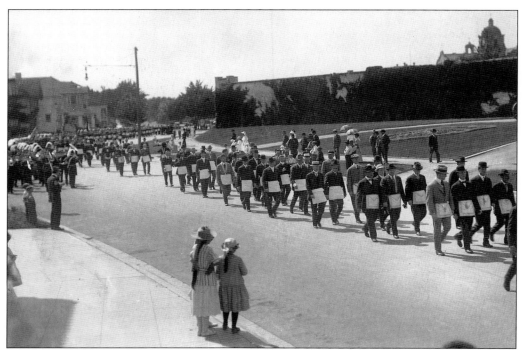

A large procession of Masons marches past the camera on L Street in this *c.* 1930 photograph. The parade participants were likely involved in a ceremony taking place at the Scottish Rite Temple, located across the street from the fort at the southwest corner of Twenty-eighth and L Streets. With Sutter's Fort as the backdrop, many organizations sought to take advantage of the historic setting. (Courtesy Sacramento Trust for Historic Preservation Collection.)

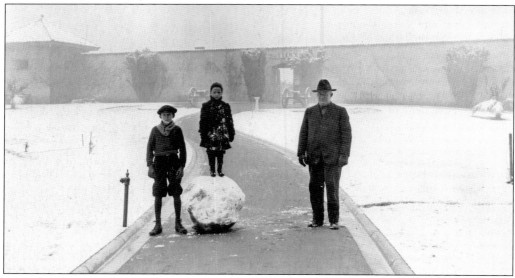

A 1922 winter wonderland, an unusual event in Sacramento, blankets the grounds at Sutter's Fort near the main gate. With its 6.2 acres, the park provided a perfect spot to begin building a snowman. One youngster proudly stands next to the oversized snowball, while the other, speckled with snow, stands atop it. (Courtesy Sacramento Valley Photographic Survey Collection.)

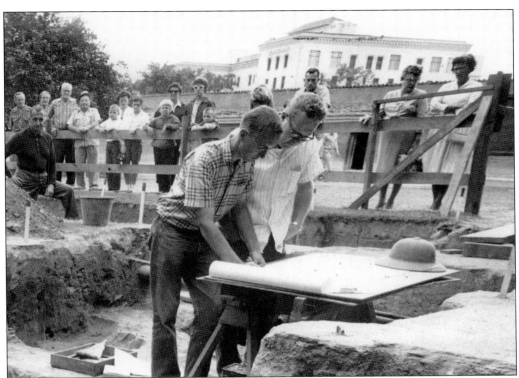

Archeological digs on the grounds have provided further insight into the activities at the fort as well as its layout. In 1958–1959, test pits and trenches were dug in the hopes of finding additional clues about the nature of 1840s California. The artifacts unearthed helped historians and archeologists better understand the eras before and after Sutter's settlement. (Courtesy *Sacramento Bee* Collection.)

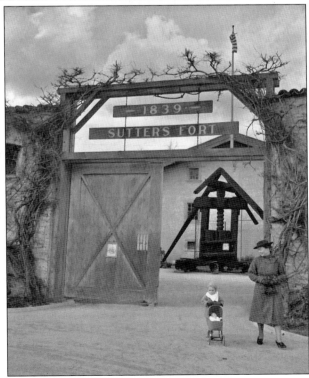

Upon entering through the main gate at 2701 L Street, the structure's modern address, visitors in the 1940s were met by a hay press. Hand carved in 1868 in Plumas County, the press was powered by horse or mule, which turned the oak screw to compact the cut grass into hay bales. This photograph captures a mother and daughter leaving after their visit. (Courtesy *Sacramento Bee* Collection.)

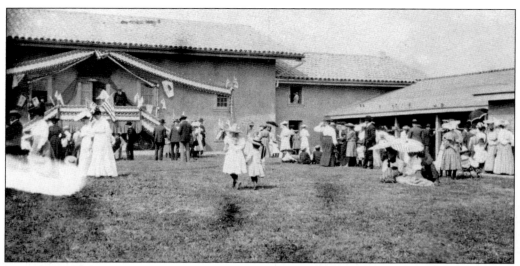

Since its restoration, Sutter's Fort has been an important place to gather for community events and celebrations. Both the Native Sons and Native Daughters of the Golden West, important organizations in the fort's renewal, have hosted numerous festivities at the park. This *c.* 1910 Admission Day celebration, commemorating California's statehood on September 9, 1850, shows a decorated central building. (Courtesy Eleanor McClatchy Collection.)

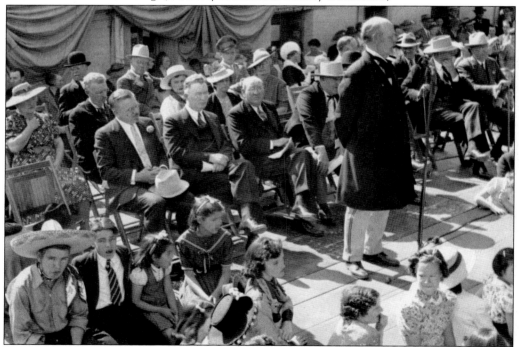

The year 1939 saw parades, speeches, and music at the fort to commemorate its 100th anniversary and the beginnings of Sacramento. On May 30, crowds gathered to hear speakers during the dedication of a bronze tablet given by the citizens of Switzerland to honor John Sutter and his Swiss origins. The event was attended by members of the United Swiss Societies of California. (Courtesy Florence Henderson Collection.)

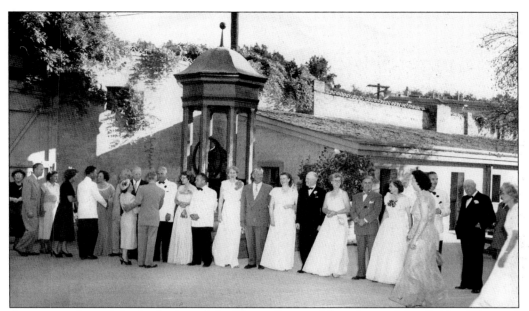

A receiving line of the leadership of the Native Sons and Daughters of the Golden West and other dignitaries, including Gov. Earl Warren (left, in dark suit facing camera), stands inside the fort's main gate, *c.* 1950. Behind the line was a tower and bell from Young America, No. 6, one of Sacramento's early volunteer fire departments. The bell once welcomed the first pony-express rider into Sacramento. (Courtesy Didion-Armstrong Collection.)

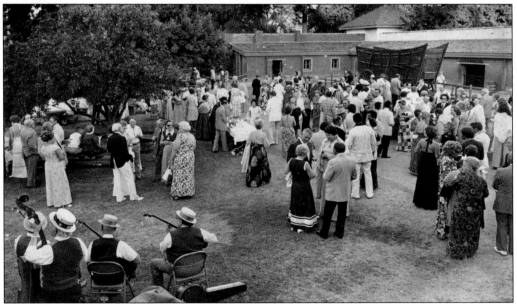

Enjoying music and drinks, a crowd celebrates Sacramento's birthday at Sutter's Fort on August 9, 1975. The birthday party marked the August 12, 1839, landing of John Sutter at present-day Sacramento, although the exact date was probably a few days later. The now defunct event was sponsored by various historical groups and organizations and often featured a birthday cake in the shape of Sutter's Fort. (Courtesy *Sacramento Bee* Collection.)

In this c. 1930 photograph, Howard Miller, a docent at the fort, poses in his costume. Although the period attire was not historically accurate, the fort used reenactors to bring early California history to life. With the hiring of Harry C. Peterson in 1926 as the fort's first curator, the fort began to organize as a museum dedicated to documenting California from 1839, when Sutter arrived, to 1869 and the completion of the transcontinental railroad. (Courtesy Sacramento Valley Photographic Survey Collection.)

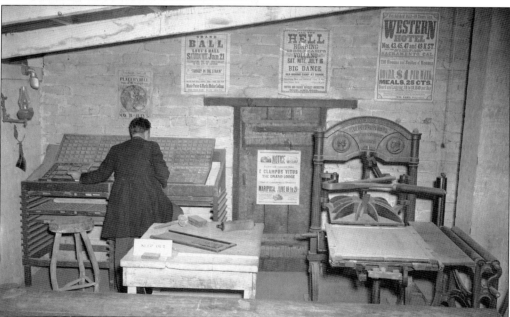

Rooms within the fort were furnished to give visitors a peek back in time at what some of their original uses might have been. In the print shop, an old hand press, type cases, and other printing paraphernalia gave museum goers a lesson in how newspapers were once published. The first newspaper in Sacramento, the *Placer Times*, was printed at the fort in 1849. (Courtesy *Sacramento Bee* Collection.)

One of the most important rooms at Sutter's Fort was the blacksmith shop. Dependent on the skills of these metal workers for the creation and repair of all metal instruments, blacksmiths were among the highest-paid workers at the fort. Just in front of the forge, with its handmade bellows, and surrounded by various tools, a modern-day blacksmith works on a wagon wheel. (Courtesy *Sacramento Bee* Collection.)

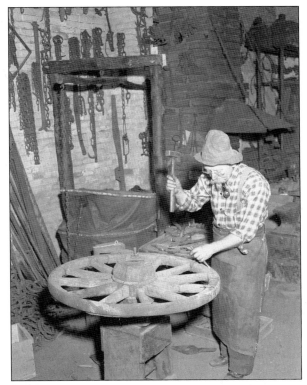

Sutter's Fort became a part of the California State Parks system in 1947. As part of its educational mission, the fort created audio tours to aid visitors in the interpretation of displays and activities at the fort. Here elementary school students studying their state's history peer into the blacksmith shop while listening via headphones during a January 1971 field trip. (Courtesy *Sacramento Bee* Collection.)

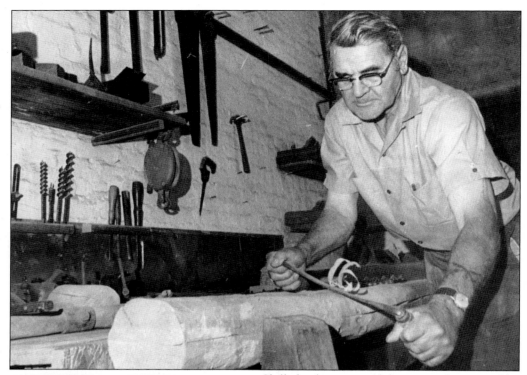

Skilled volunteers and docents make it possible for the fort to host "Living History Days" and "Pioneer Demonstration Day," where visitors can watch activities as they would have been done in 19th-century California. Working with a log, carpenter Oscar Reippel begins to fashion what eventually will be a bed for one of the fort's exhibits in this August 1972 photograph. (Courtesy *Sacramento Bee* Collection.)

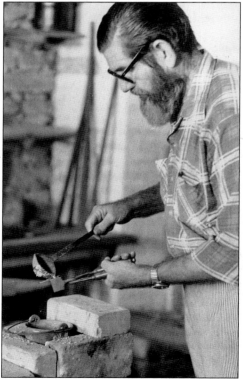

During History Week in August 1979, George Carlin demonstrates in the fort's armory how bullets were made. The molten lead is poured into a bullet mold and then allowed to cool and harden. Skilled craftspeople use period-appropriate tools and materials to educate visitors on the realities of everyday life at Sutter's Fort. Interacting with these volunteers is a vital part of the living history program. (Courtesy *Sacramento Bee* Collection.)

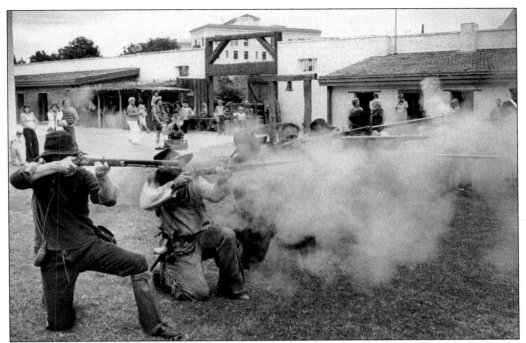

Sacramento Bee photographer Frank Stork was present at one of the fort's Living History Days in June 1980 and took this view near the main gate—a pioneer militia drill in the west yard, with black powder rifles, recreating a scene from 1846 with a bang. These volunteers and others from the Coloma Crescent Theater players showed spectators pioneer life in the Old West. (Courtesy *Sacramento Bee* Collection.)

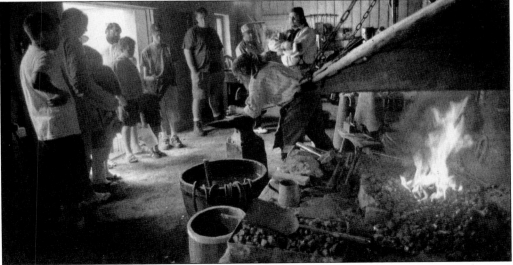

The annual Mountain Man/Pioneer Traders and Crafts Faire draws a large crowd each April to Sutter's Fort. Costumed docents provide hands-on demonstrations and activities, including spinning, blacksmithing, and bread baking, while vendors offer 1840s wares for sale. In this 1999 photograph, blacksmith Dennis "Biscuits" Brehm teaches an observant group the art of a bygone trade. (Courtesy *Sacramento Bee* Collection.)

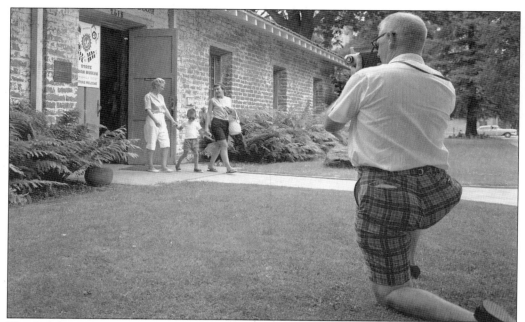

The California State Indian Museum opened on December 15, 1940, at the northwest corner of the fort grounds, facing K Street. The museum offers visitors a glimpse into native Californian life with its rich collection of basketry, clothing, and other cultural artifacts. This July 12, 1961, photograph shows Dr. L. W. Roth, of Folsom, photographing his wife, daughter, and grandson Paul as they exit the museum. (Courtesy *Sacramento Bee* Collection.)

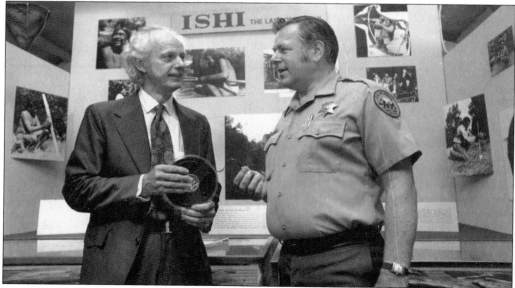

Dr. Robert Hewitt (left), an anthropology professor at American River College, and Kirby Morgan, Sacramento area manager for the State Department of Parks and Recreation, discuss the opening of the museum's new exhibit and film in June 1973. The museum is home to a large display on Ishi, the last of the Yahi Indians, who was discovered in 1911 near Oroville still living via traditional means. (Courtesy *Sacramento Bee* Collection.)

Indian Agency of New Helvetia
May, 22d 1847.

Cornelio Chief of the Shonomney tribe has presented himself here, on my request, to receive my Orders and Instructions.

The said Chief promised faithfully that he and his tribe will in future have nothing more to do with Horsestealing, nor trading horses with the Horsethiefs; therefore I request the Commanding Officer of the expedition against the horsethiefs, to not molest the Shonomney tribe, as they are willing to obey the Orders of the Government.

The Shonomney tribe could be very usefull by assisting to subdue the hostile Chausiles & Potoaches on the River Merced, which two tribes dont like to abstain from horse stealing nor do they like to surrender and enter in friendly relations with me.

J. A. Sutter
Sub Agent for the Indians on & near the Sacramento & San Joaquin Rivers.

Much has been written on the relationship of John Sutter with the local native population, mainly the Maidu and Nisenan peoples. There is currently an ongoing debate about how Sutter should be portrayed—as a villain who exploited the locals or a hero who was a product of his time and was fallible yet worthy of praise. Perhaps it is a combination of these descriptions. To be sure, the relationship between the two groups viewed by today's standards would be questionable at the least. However Sutter walked a fine line to provide something of value in exchange for the assistance his fledgling colony desperately needed to survive. It was only through native assistance that the fort was built, the fields plowed and harvested, a militia organized, trade commenced, and an economic system established, but clearly both parties played an active role. The above 1847 letter is an example of this complex relationship. Both Sutter and Cornelio, the Shonomney chief, set the policy of interaction, hoping it would be to the advantage of both groups. (Courtesy Eleanor McClatchy Collection.)

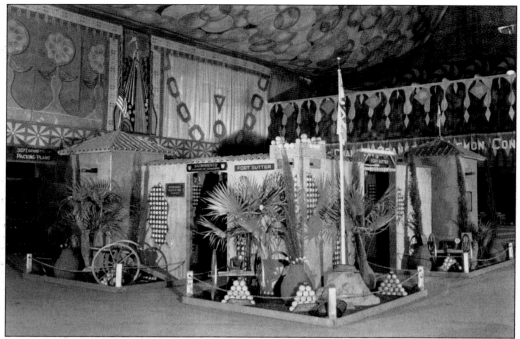

Sutter's Fort is synonymous with Sacramento and vice versa. This 1930s photograph shows the Sacramento Chamber of Commerce's display in the Agricultural Pavilion at the state fairgrounds on Stockton Boulevard. Fair goers were treated to locally grown oranges upon visiting the replica. Marketing the fort has been necessary for area businesses, farmers, politicians, educators, preservations, historians, photographers, and the city's proud citizens. (Courtesy Sacramento Metropolitan Chamber of Commerce Collection.)

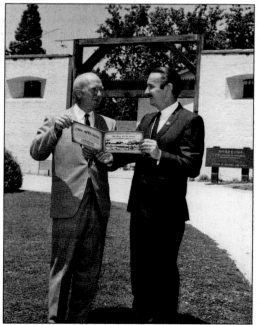

John H. Sievers (left), secretary-treasurer of Fort Sutter Savings and Loan Association, and Frank S. Christy, president of the Sacramento County Historical Society, proudly review the first copy of the illustrated booklet, "The Story of Fort Sutter," in front of the fort's main gate. The promotional booklet, developed by the loan association, proudly tied its history to that of Sutter's Fort, even altering the structure's name to match that of the financial institution. (Courtesy Frank Christy Collection.)

Two

Boulevard Park Corridor
C through I Streets
By Shawn Scarborough

Sacramento is laid out in a grid with lettered streets running east and west and numbered streets running north and south. The corridor encompassing Boulevard Park, New Era Park, and the homes surrounding it supported a mix of upscale dwellings and working-class residences, along with businesses and manufacturers that took advantage of the nearby railroad tracks. Bounded on the north by the American River, the Boulevard Park corridor was first home to the Union Park Racetrack and the California State Agricultural Society Fairgrounds.

The state fair operated the racetrack at Twenty-first, Twenty-second, and B through H Streets from 1861 until Park Realty Company purchased the tract and created Boulevard Park, the first large-scale residential development catering to wealthy business owners in 1905. The neighborhood was divided into large lots with wide streets that gave the upper middle-class development a park-like feel.

The adjacent district, New Era Park, emerged in the late 1910s as a working-class neighborhood with affordable housing for employees of some of the major Sacramento business, including nearby Southern Pacific Railroad; California Packing Corporation, makers of the Del Monte brand; and the California Almond Grower's Exchange, makers of the Blue Diamond brand. In addition, the Northern California Milk Producers Association provided employment for a large portion of the population living in the area. These businesses, together with the construction of the trolley line from C Street to J Street, brought an influx of citizens to the growing locality.

As the corridor matured, other types of businesses and services opened in the district to serve the needs of the community. Corner grocery stores and a meat market, a staple of most neighborhoods, began to serve local customers. Churches established congregations in the area. Even gas stations, with the advent of the automobile, found a niche in the neighborhood. Today Boulevard Park and New Era Park, along with the entire corridor, are undergoing revitalization and have active neighborhood associations that are keeping the identity of the region alive and thriving.

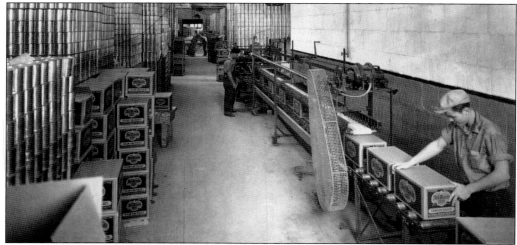

Built in 1925, this is the interior of the California Packing Corporation's "Plant 11," located at 1701 C Street. The 1926 photograph shows workers processing cases of Del Monte canned vegetables. Del Monte was one of many of the brand names used by the California Packing Corporation (Cal-Pac), the result of a merger of five companies. Cal-Pac eventually changed its name to the Del Monte Corporation. (Courtesy Sacramento Metropolitan Chamber of Commerce Collection.)

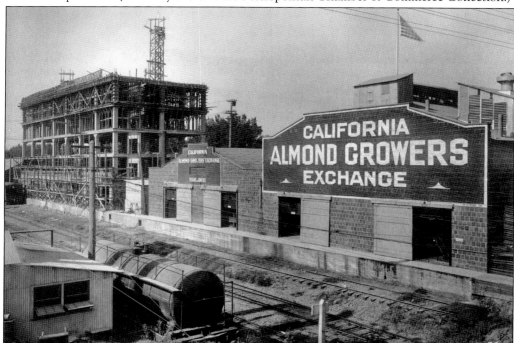

The California Almond Growers Exchange (CAGE) was founded in Sacramento in May 1910. In 1914, to help boost sales of shelled almonds, CAGE constructed an almond-shelling plant at Eighteenth and C Streets, along with a railroad spur. This c. 1929 image shows the five-story processing plant being constructed alongside the warehouses, one of many additions and improvements during the history of the organization. (Courtesy California Almond Growers Exchange Collection.)

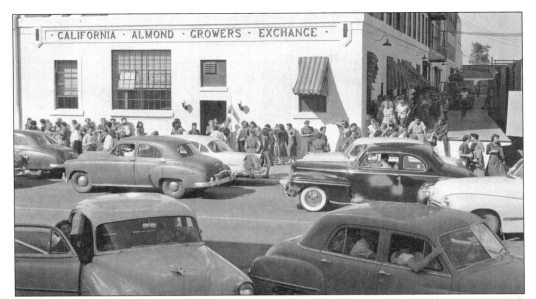

This c. 1955 photograph of a shift ending shows just how busy the operation had become. In 1915, the general offices were moved to San Francisco. By 1938, the offices were moved back to Sacramento to a new building facing the processing plant. The number of employees had also risen substantially. In the 1950s, a cold-storage unit and concrete storage bins were built, while a worldwide marketing campaign began in 1955. (Courtesy California Almond Growers Exchange Collection.)

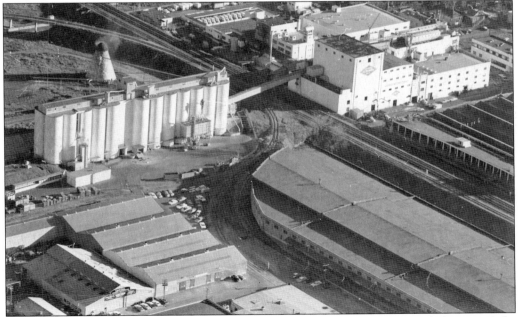

The California Almond Growers Exchange is seen in this January 1967 aerial photograph by Robert Handsaker. CAGE is the oldest agricultural cooperative in the state and one of the most successful with its Blue Diamond brand of products. With the building of the Visitor's Center and Growers Store at Seventeenth and C Streets, today a popular tourist stop, the operation has grown since this image was taken. (Courtesy Sacramento Bee Collection.)

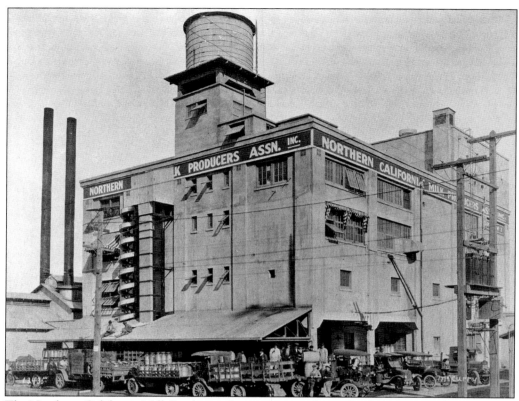

The Northern California Milk Producers Association was located at 214 Nineteenth Street. The buildings were constructed in 1918 and 1954. The plant was sold to Golden State in 1927, which began processing milk and ice cream at the plant in 1929. Golden State was the largest dairy in California by the 1930s. Golden State's merger with Foremost Dairies in 1954 created one of the largest dairies in the country. (Courtesy Ralph Shaw Collection.)

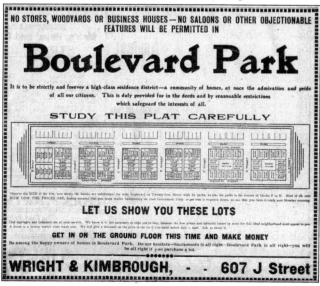

Advertisements for the new Boulevard Park neighborhood in the *Evening Bee* were used to sell property in the developing neighborhood. The plat map shows the two hidden parks between F and H Streets. Each lot came with a cement sidewalk and the promise of being a corner lot or bordering a park. This advertisement guaranteed that Boulevard Park would begin as, and remain, an upscale neighborhood. (Courtesy *Sacramento Bee* Collection.)

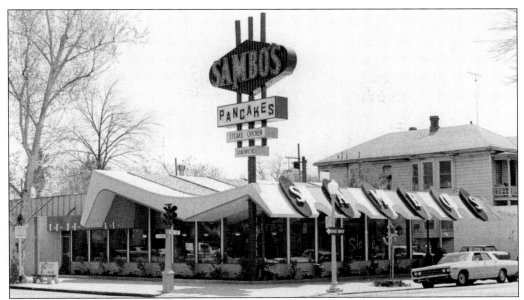

The Sambo's restaurant chain was founded in Santa Barbara in 1957. This store at Sixteenth and F Streets, the fifth in the Sacramento area, was built in 1965 at a cost of $400,000. The chain once had 1,200 restaurants nationwide but failed partially because of overexpansion. The negative racial connotations of the name, made common by the book *The Story of Little Black Sambo*, made the restaurant a target of backlash and eventually helped in its demise. (Courtesy *Sacramento Bee* Collection.)

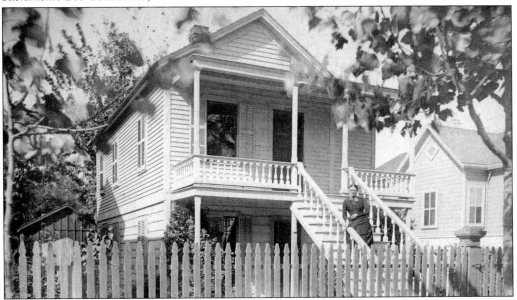

Pauline Paul is pictured standing on the stairs of her home at 618 Sixteenth Street in this c. 1895 photograph. Pauline lived here with her husband, Philip, and their daughter Ernestine until the 1920s. This simple Delta-style residence is illustrative of the size of typical middle-class homes in Sacramento. Philip spent his working life at the Southern Pacific shops, moving his way up from a helper to become a jacketman working on boilers. (Courtesy Ernestine Paul Collection.)

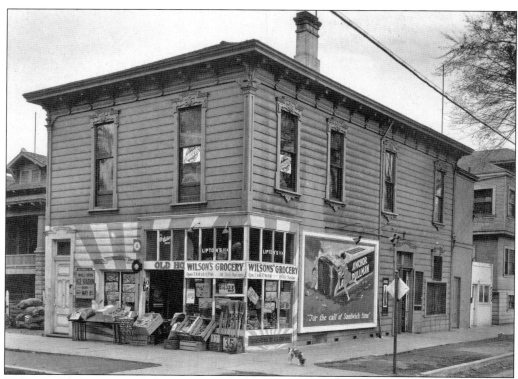

Wilson's Grocery at 1631 F Street, *c.* 1930, was typical of neighborhood grocery stores in the early 1900s. Corner markets served the everyday needs of the neighborhood residents. This photograph was taken not long after the store changed hands, as seen by the canvas signs covering the former name. Note also the billboard attached to the side of the building; this was a primary form of advertising at the time. (Courtesy David Joslyn Collection.)

The United Brethren Church, located at Nineteenth and F Streets, was built in 1904. The church was organized in 1881; many early members were of Swiss descent and services were held in German. The architecture of the church was reminiscent of churches early members left behind in Europe. (Courtesy Eugene Hepting Collection.)

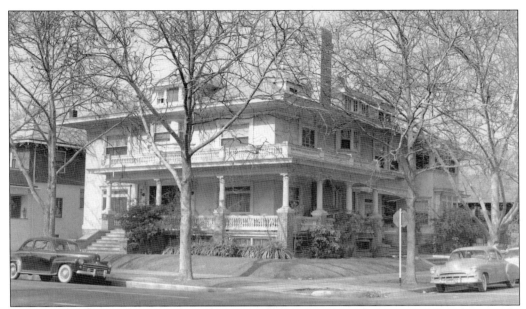

The Dalton Residence at 2131 F Street is Prairie and Colonial Revival in style. This photograph, taken February 1955, captures the wraparound flat-topped porch and bow windows. The home was built in 1913 for Edward F. Dalton, vice president-treasurer of California State Life Insurance Company. (Courtesy Ralph Shaw Collection.)

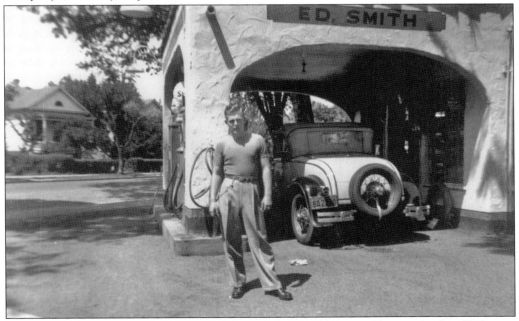

Ed Smith is pictured standing in front of his Super Service Station at Twenty-third and F Streets in this c. 1940 photograph. Neighborhood service stations were a place to socialize as well as buy fuel. The automobile, popular by the 1920s, was one of the most important economic forces in Sacramento. Service stations, such as this, sprang up to meet the growing needs of automobile owners. (Courtesy Carol Allen Collection.)

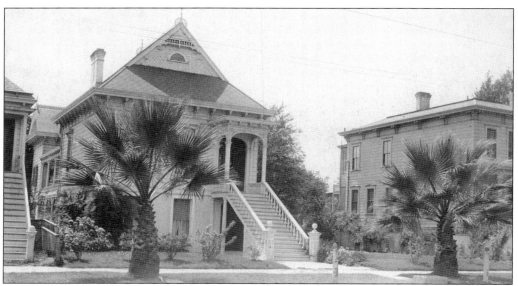

The Washburn family home at 1826 G Street was built *c.* 1905 in the Delta style. These houses are distinguished by the finished ground floor with the main entrance at the second floor. This design was popular in the Sacramento region, as the area was prone to flooding. Note the decorative circular details at the roof peak. (Courtesy Eleanor Lorenz Collection.)

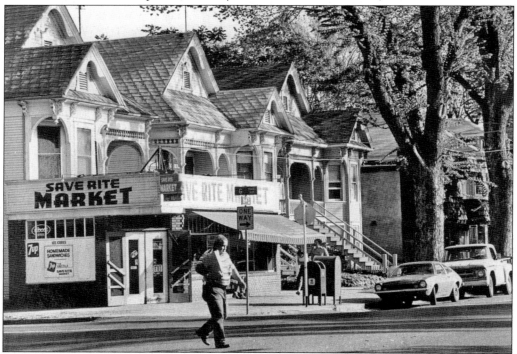

The Save Rite Market on 701 Nineteenth Street has been owned and operated by the same family at this location since 1955. The market continues to fulfill the grocery needs of neighborhood residents, even with the emergence of large chain grocery stores. The market was built on the facade of a Delta Victorian residence. (Courtesy *Sacramento Bee* Collection.)

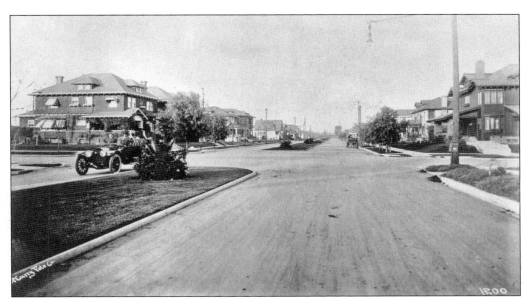

A street scene, c. 1915, looks north on Twenty-first and G Streets in the recently developed Boulevard Park neighborhood. A "park" down the center of the wide street was a draw to new residents and was unique to the neighborhood. This park-like setting was the reason for naming the neighborhood Boulevard Park. Note the beautiful Transitional Craftsman homes lining the street. (Courtesy Sacramento Metropolitan Chamber of Commerce Collection.)

This large Federalist-style house at 2120 G Street was once home to Henry Bernard Drescher, a wholesale grocer with Mebius and Drescher, as well as vice president of Buffalo Brewery. The home has often been used for various commercial enterprises, including a dance studio and an interior design firm. In this photograph from 1983, the large building had been converted into Aunt Abigail's Inn, a five-room bed-and-breakfast. (Courtesy *Sacramento Bee* Collection.)

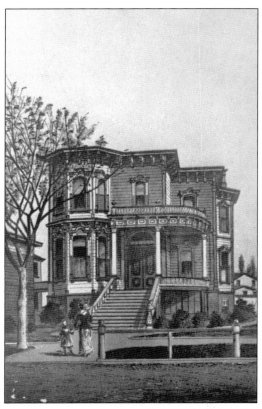

The Queen Anne residence at 1623 H Street was the *c.* 1890 home of L. L. Lewis, a prominent printer. This drawing was reproduced using the rotogravure technique, which captures the decorative window frames and porch detailing. The rotogravure technique was a mechanized form of printing that was popular at the turn of the 20th century. (Courtesy *Sacramento Bee* Collection.)

This *c.* 1905 photograph shows Harris Weinstock (seated at right) with an unidentified man in a horse-drawn buggy in front of his Queen Anne–inspired residence at 1631 H Street. Harris was cofounder of Weinstock-Lubin Department Store, which opened in the 1850s as the Mechanics Store. The store became well known for its one-price policy, thereby avoiding the haggling over prices, a common practice during the time. (Courtesy Weinstock Collection.)

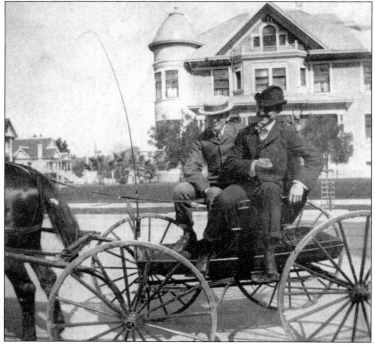

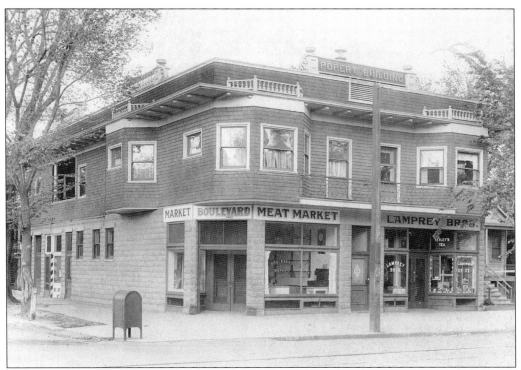

The Boulevard Meat Market at Twenty-first and H Streets is a Craftsman structure with Prairie-school elements. As with Wilson's Grocery (pictured on page 34), this is a typical combination of business and residence with the top floor reserved as living space. Meat markets such as this were necessary, as neighborhood grocery stores did not usually sell meat. (Courtesy Vandercook Collection.)

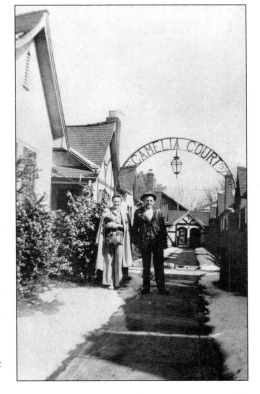

Inspired by the growing Scandinavian community in Sacramento, the Camelia Court bungalows at 2309–2315 H Street reflected the design often found in Danish neighborhoods—small bungalows facing a common area or court. Marie and Christian (right) Madsen, employees of Mason-Cascade Laundry, were the managers of Camelia Court during the 1930s and 1940s. They lived in apartment C at 2309 H Street and posed for this photograph during the snowstorm of March 14, 1942. (Courtesy Sacramento Ethnic Survey Collection.)

The residence at 2330 H Street, an area known as "Merchants Row," was built in 1893 for M. K. Barrett, an officer at the Sacramento Savings Bank. This 1973 photograph of the Queen Anne residence with Eastlake elements shows the decorative circular detailing in the wooden siding, as well as the spool work on the porch. Note the intricate frieze and spindle work at the roofline. (Courtesy Lloyd Fergus Collection.)

This intriguing residence at the corner of Twenty-second and H Streets was built in 1907 by the founder of Sutter Hospital, Dr. Aden C. Hart. The house is of Colonial Revival style but built with Craftsman materials and details. The first floor is artificial stonework with a carved lion's head over the entrance to the porch, while the second story is shingled and has several stained-glass windows. (Courtesy Lloyd Fergus Collection.)

Named Tres Petit Auberge, or "Very Little Inn," the residence at 811 Twenty-sixth Street was possibly a boardinghouse or small hotel. Originally built as a single-family home in 1911 by Henry G. Biegel, he added the second story, pictured here, in 1916. He operated Biegel Refracting and Manufacturing Company and worked as an optician. Biegel lived at 811 ½ and rented out 811 to tenants. (Courtesy *Sacramento Bee* Collection.)

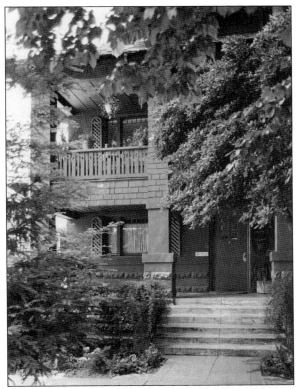

The interior of Clauss and Kraus at 1700 I Street, *c.* 1920, shows customers, employees, meat scales, and an old exterior sign. Clauss and Kraus was the first butcher shop in Sacramento to refrigerate their meats with ice shipped in from Donner Lake in the Sierra Nevada. Clauss and Kraus began as a small business run by brothers-in-law and quickly became one of the largest meat processing and packing plants in Sacramento. (Courtesy Sacramento Valley Photographic Survey Collection.)

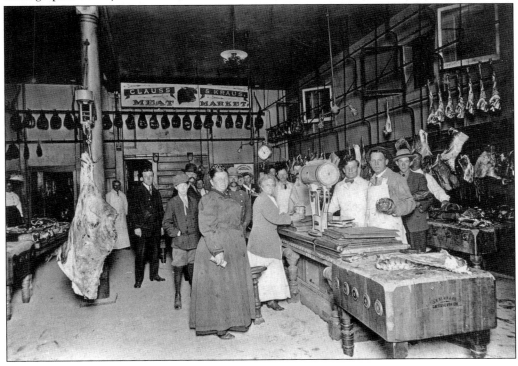

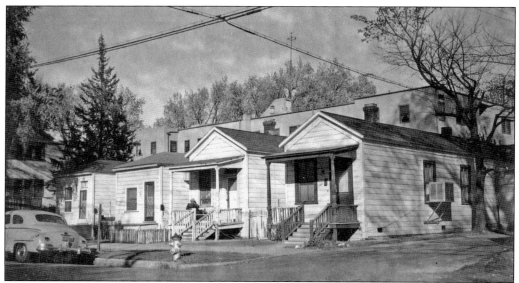

Small row houses located on the east side of Twenty-second Street between I and J Streets were built around 1900. These houses were most likely homes for local factory and Southern Pacific workers. Sacramento was home to regional processing plants for almond growers and fruit and vegetable farms as well as dairy operations. (Courtesy Eugene Hepting Collection.)

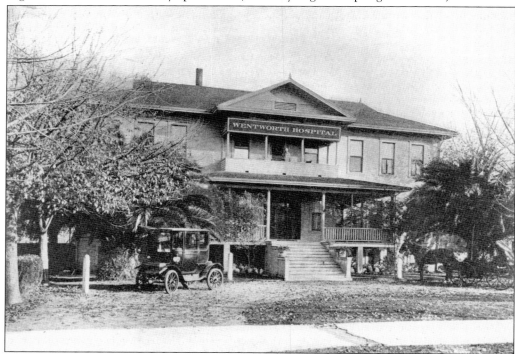

Pictured here in 1915 is the Wentworth Hospital at 2615 I Street. Opened in September 1900 by Dr. William L. Wentworth, the center had 25 beds. The hospital was taken over after his death by Louise Igo and closed in early 1915. The early automobile on the left could have been put to use as an ambulance. (Courtesy Eugene Hepting Collection.)

Three

CORRIDORS OF COMMERCE
BUSINESS IN THE DISTRICT
BY DYLAN MCDONALD

Sacramento's Midtown has historically been a residential area, with a few pockets of business and industry. The streets at the center and edges of Midtown naturally evolved into corridors of commerce. Some of this was an outgrowth of development moving east from the Sacramento riverfront of J and K Streets. Other streets began to develop as a result of the growing suburbs of Alhambra and Broadway. All of them, including Sixteenth Street, served as important links in the city's transportation grid.

Crossing Sixteenth Street, the larger commercial structures on J and K Streets give way to mixed-use structures. Many of the buildings traditionally housed mom-and-pop-style businesses on the first floor and apartments or rooms for rent on the second. Scores of old Victorian homes, remnants of the area's residential past, have been converted into office space for white-collar businesses or transformed into studio apartments. A recent infusion of redevelopment has brought new construction along J and K Streets, with numerous restaurants, coffee houses, and stores catering to Sacramento's fashionable and trendy.

Alhambra Boulevard and Broadway, border streets between the original city and its emerging suburbs, each were the result of name changes to reconfirm their status as important commercial areas. In February 1927, the city council authorized a name change for Thirty-first Street. With the opening of the new symbol of East Sacramento, the picture palace Alhambra Theatre, the civic-minded felt that developing businesses along the newly named Alhambra Boulevard would prove easier. Y Street was rechristened Broadway in 1938 with the opening of the Broadway Tower Theatre. Hoping to create a new entertainment district near the new residential Land Park suburb, Y Street/Broadway moved beyond its status as the levee that protected the city's southern boundary from rising floodwaters.

Much of Sacramento's heavy industry was centered near the Sacramento River waterfront and the rail lines of the Southern Pacific and, therefore, in downtown. Yet Midtown still had its hotbed of industrial activity, including R Street and the area around Sixteenth and C Streets. As midpoint of the city's original grid, Sixteenth Street also served as an important transportation route, moving traffic as part of the national highway, U.S. 40.

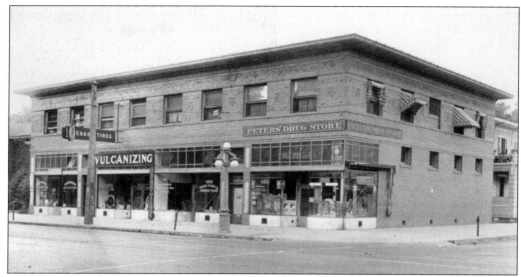

The two-story building once located at the southeast corner of Sixteenth and J Streets was home to, among others, Wesley W. Rusk's vulcanizing business. In 1922, Rusk ran one of 15 such companies in town. His shop focused on tires, but other objects, from clothing to umbrellas, could also undergo the chemical process of curing rubber, thereby prolonging the product's useful life. The building's second-floor rentals made up the J Street Apartments. (Courtesy Vandercook Collection.)

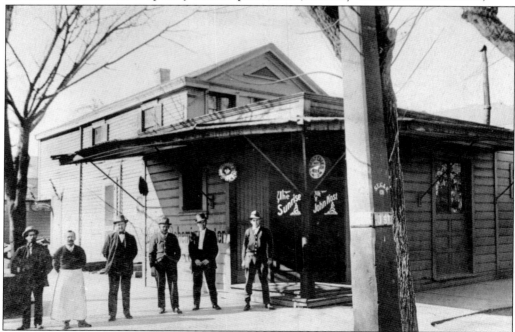

Advertising the locally made Ruhstaller's Gilt Edge Lager and Steam Beer, John Kost's saloon operated at the southwest corner of Seventeenth and J Streets. The saloon catered to the men employed by the nearby Southern Pacific Railroad shops. At that time, women were prohibited from saloons, but the side door at the left of this c. 1900 photograph indicates where they were allowed to enter and purchase pails of beer, or "growlers," for home use. (Courtesy *Sacramento Bee* Collection.)

In 1955, local businessman Sam Gordon opened his German-inspired restaurant, Sam's Hof Brau, at the same 1630 J Street address once occupied by Kost's saloon. Serving up carved meats and steamed vegetables, as well as plenty of beer, the eatery also proved to be the place in Sacramento for live blues music. Gordon sold his chain of restaurants to Denny's in 1968, and the J Street location eventually closed in 1993. (Courtesy *Suttertown News* Collection.)

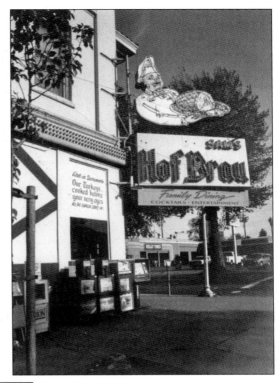

Newbert Hardware operated at the southeast corner of Seventeenth and J Streets, serving local contractors, farmers, and handymen, as in this February 1984 photograph. Celebrated for its knowledgeable staff and the place to get that hard-to-find item, the business called the location home from 1937 until 1993, when the store closed due to increased competition. Since 1994, the building has been home to The Beat, an independent music store. (Courtesy Glen T. Vanderford Collection.)

Completed in October 1909, the Western Pacific Railroad's Mission Revival–style station at Nineteenth and J Streets provided service to San Francisco and Salt Lake City. Freight service began in December 1909, while passenger service commenced the following August. As seen in this 1981 photograph of the arched entryway, the building, designed by San Francisco architect Willis J. Polk, is now occupied by the Old Spaghetti Factory restaurant. (Courtesy *Sacramento Bee* Collection.)

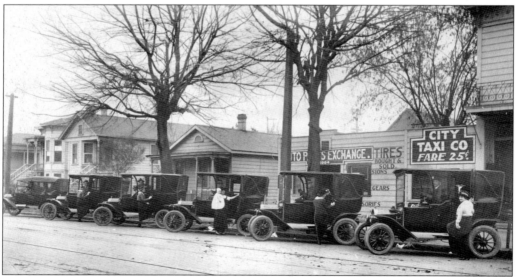

Proudly displaying their fleet of Model T Fords during this New Year's Day 1915 photograph, the City Taxi Company's automobiles lined J Street. Located at 2004 J Street, the company's five taxis offered a 25¢ fare. Posing with his taxi, third from the right, is Robert Vargas Sr. with his wife and 14-month old daughter, Dolores. (Courtesy *Sacramento Bee* Collection.)

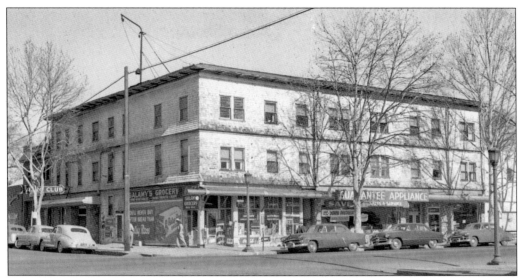

Documenting mixed use that is synonymous with urban living, the Sacramento Apartments, at the northeast corner of Twentieth and J Streets, had some 30-plus apartments. In this February 1953 photograph, the building's first floor is occupied by the Aero Club tavern, Salamy's Grocery, the Appliance Center, and a realty and insurance office. Today the building is home to Original Pete's, best known for its pizza and hot wings. (Courtesy Ralph Shaw Collection.)

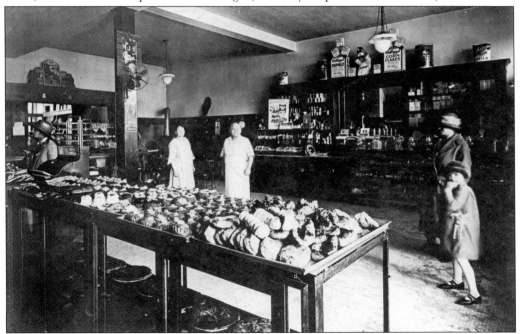

Russian immigrants Alexander (center) and Pasha Opanasenko (left) married in San Francisco in 1910, Americanizing their last name to "Ansen." After working as a baker in several hotels in San Francisco and Sacramento, Alexander opened a European bakery at 2020 J Street in 1917 and ran it until his death in 1934. The family, which included daughter Mary, lived on the second floor above the neatly kept bakery. (Courtesy Mary A. Hennessey Collection.)

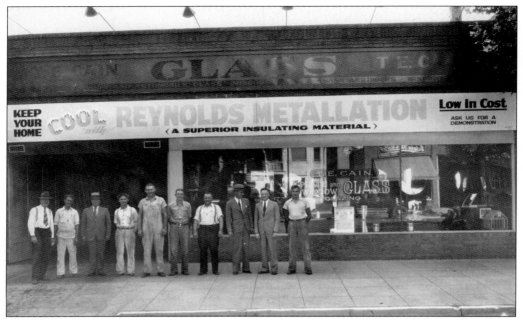

Glass dealer T. E. Cain operated at 2416 J Street. A family-run business, the shop offered plate and window glass for office, home, and automobiles. Pictured out in front of the establishment on September 15, 1935, with his employees is owner Thomas E. Cain (far left) and his son J. Edward Cain (second from right), the store manager. Another son, Percy J. Cain, worked as a glazier. (Courtesy Noel Alton Collection.)

This 1926 photograph captures several persons and businesses on the southwest corner of Twenty-eighth and J Streets. Designed by C. K. Aldrich and built in 1922 by George Hudnutt, the corner building housed both Born Brothers Grocers and Soost Brothers Meats through 1941. Next door were Paul H. Fletcher Drugs at 2728 J Street and the old Fort Sutter U.S. Post Office at 2724 J Street, which sat in the middle of the block. (Courtesy McCurry Company Collection.)

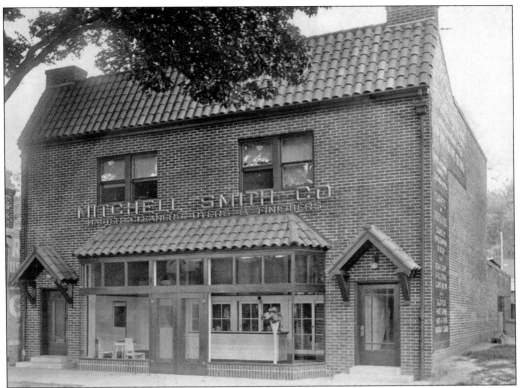

Emma A. Mitchell and her husband, Leon, ran the Mitchell-Smith Company cleaning business at 1612 K Street. The structure was built in 1922 by the construction firm Betz and Mabrey for nearly $19,000. Making use of an ideal Midtown design, the building is nearly identical to the Fletcher Drugs store in the previous photograph; Betz and Mabrey having started construction on the J Street building about three months prior. (Courtesy Vandercook Collection.)

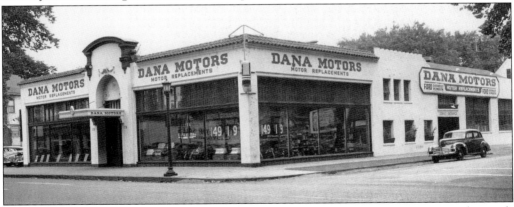

With the rise of the automobile in American culture, numerous businesses catering to the needs of drivers flourished. Midtown provided plenty of choices for automobile repairs with nearly 50 such shops when this photograph was taken around 1950. Dana Motors, at the northwest corner of Eighteenth and K Streets, specialized in motor repairs of Fords, Chevys, Dodges, Plymouths, and Zephyrs. Owner Leslie V. Dana oversaw the rebuilding and distribution work. (Courtesy Eleanor McClatchy Collection.)

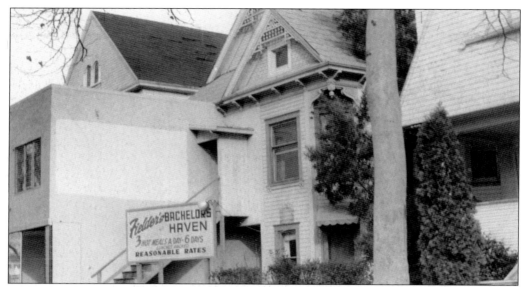

Photographer Gunther Grumm snapped this image of Fielder's Bachelors Haven at 1829 K Street in 1958. Operated by Thomas H. and Bessie Fielder, the home catered to a growing need in the urban area—renting rooms to single men. As commercial development marched eastward along J and K Streets, former residential structures turned into commercial enterprises or faced the wrecking ball. The Fielders also ran another rental, Fielder's Manor House on I Street. (Courtesy Gunther Grumm Collection.)

Midtown has seen its share of large grocers and supermarkets—Cardinal, Safeway, Lucky, Stop-N-Shop, and Raley's. A northern California chain, Raley's first store opened in Placerville in 1935. Offering the first prepackaged-meat and natural-food departments, the business soon expanded into Sacramento. This Raley's store at Twenty-eighth and K Streets in the Fort Sutter Shopping Center closed in May 1983 due to expansion from neighboring Sutter General Hospital. (Courtesy *Suttertown News* Collection.)

Even while concrete cured, business carried on in this 1948 photograph looking east on Broadway (formerly Y Street). The street was once home to numerous gas stations and used-car dealerships and marked the boundary between Midtown and the suburbs. At 2401 Broadway was Claude Schoener's service station, specializing in repairing Pontiacs. Next door was Sterling Cleaners, run by Hidde P. Wierdsma, a licensed "Sanitone" cleaner. (Courtesy Eugene Hepting Collection.)

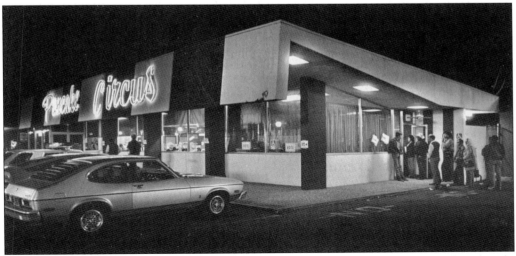

A crowd waits outside the Pancake Circus restaurant not for a table but for a polling booth. Certainly one of the most unusual polling places in Sacramento, the eatery hosted voters during this November 1982 election. Opening in the early 1970s and located at the corner of Twenty-first and Broadway, the Pancake Circus's décor and its complete breakfast menu make it a local icon. (Courtesy *Sacramento Bee* Collection.)

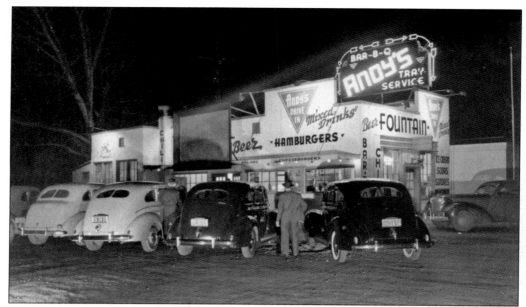

With its dramatic neon sign and well-lit facade, Andy's Drive In aimed to draw weary travelers off U.S. 40 (today's Highway 160) for a meal. South of the bridge over the American River at 560 North Sixteenth Street, Andrew J. Swenson catered to a large crowd, as this 1939 photograph shows. The restaurant offered a range of eats, from barbeque dishes to salads as well as a full bar. (Courtesy Sacramento Valley Photographic Survey Collection.)

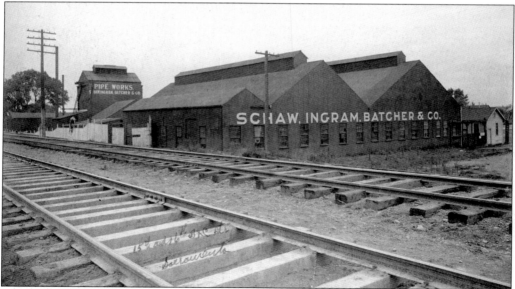

Like the industrial businesses along R Street, the intersection of Sixteenth and C Streets was home to several large manufacturing plants. With a Southern Pacific rail line bordering their plant, making shipping to all points easy, the Schaw, Ingram, Batcher, and Company pipe works sent products north to Oregon and east to Nevada. Established in 1893, the plant produced pipes for mining, irrigating, waterworks, and power purposes for the growing region. (Courtesy Frank Christy Collection.)

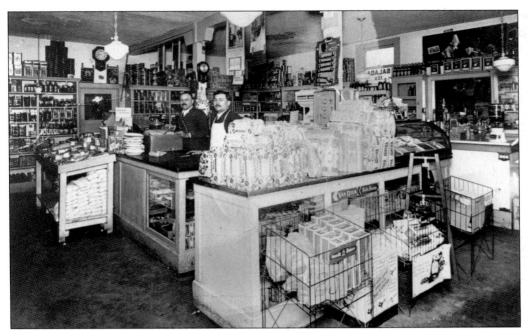

The market at 431 Sixteenth Street was originally called the Capital Grocery. Operated by Peter Kraljev (left) and Nick Zanze (right), the store sold many of the same brands recognizable today—Wonder bread, Lipton tea, and Milky Way candy bars. With the change in the economy after October 1929, the store was renamed the Capital Cash Grocery. In this 1930 photograph, several signs remind customers, "Please do not ask for credit." (Courtesy *Sacramento Bee* Collection.)

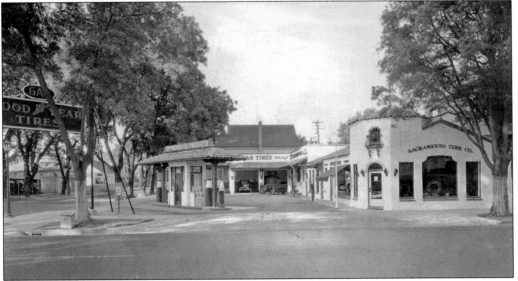

Opening on July 13, 1929, at the corner of Sixteenth and L Streets, the Sacramento Tire Company sold more than 4,600 gallons of fuel that first day. With a prime location catering to traffic along U.S. 40 (today's Highway 160), the station offered Goodyear tires and Standard Oil products exclusively. The station introduced a new "one-stop station" model to Sacramento—pumping gas, checking oil, and selling tires. (Courtesy Retail Credit Association Collection.)

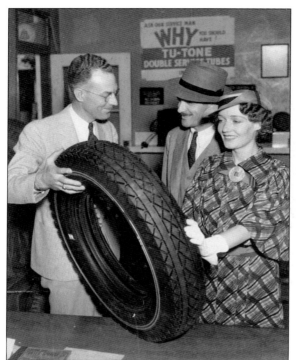

Sacramento Tire Company manager S. S. Sherman shows prospective buyers a sample of his store's Goodyear tires around 1930. Sherman believed in the business model, "If we can get the motorists to come regularly to our place of business, we can sell them more tires." Station attendants were trained to pleasantly ask drivers if they could fill the tank with gasoline while also checking the automobile's oil, battery, radiator, windshield, and tires. (Courtesy Retail Credit Association Collection.)

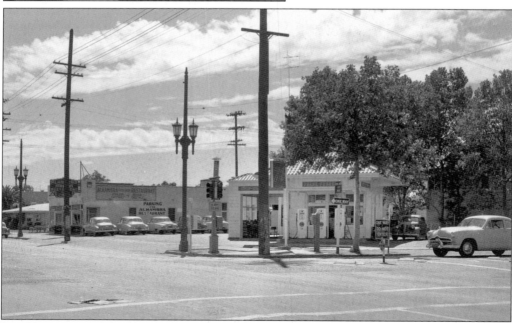

Local historian Ralph Shaw was interested in documenting the history of Sacramento's original grid through photographs. This image of the southwest corner of Alhambra Boulevard (formerly Thirty-first Street) and J Streets was taken at 2:30 p.m. on Sunday, August 29, 1954. Pictured here, looking south, are Frank Fuhrer's Drive-In Service station, with its three gas pumps, and the busy Alhambra Italian Restaurant and Café. (Courtesy Ralph Shaw Collection.)

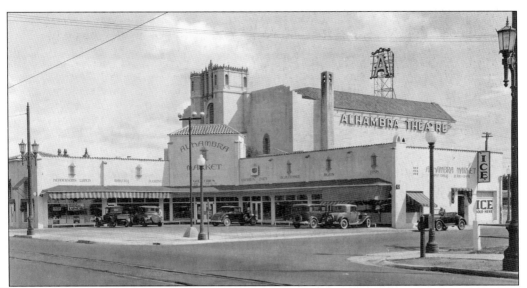

The Alhambra Drive-In Market was open daily from 8:00 a.m. to 10:00 p.m. Built in 1931 at the northeast corner of Alhambra Boulevard and K Streets, the Sacramento Chamber of Commerce proudly described the structure as "typically Californian" and one of 11 such structures recently built in the city. Immediately adjacent to the Alhambra Theatre, the supermarket contained a bakery, deli, florist, and lunch counter. (Courtesy Sacramento Metropolitan Chamber of Commerce Collection.)

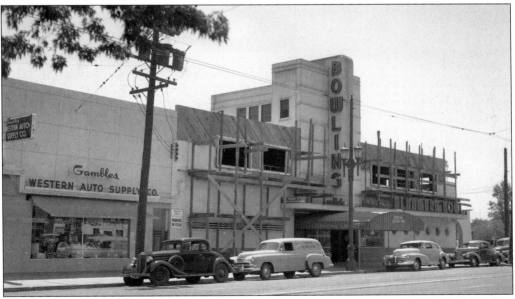

Undergoing a face lift in 1951, this photograph of Alhambra Bowl documents an era when bowling was a cultural phenomenon. Bowling offered Sacramentans, with its large and growing middle class, both a participatory and social sport. The booming postwar years saw bowling alleys become important family entertainment centers, with game rooms, snack bars, and cocktail lounges. The 16-lane alley near Folsom Boulevard opened in 1942 and burned down in 1984, two years after closing. (Courtesy *Sacramento Bee* Collection.)

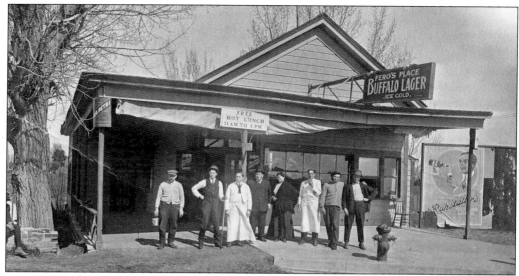

In this 1912 photograph, patrons and employees of Fero's Place pose for the camera on a cool day at the corner of Thirty-first and M Streets (today's Capitol Avenue). Serving ice cold, locally brewed beers—Ruhstaller's Gilt Edge Lager and Buffalo Bohemian Lager—and free hot lunches, regulars also tried their hands at pool, as attested by the gentleman with the pool cue (second from the left). (Courtesy Bette Robinson Collection.)

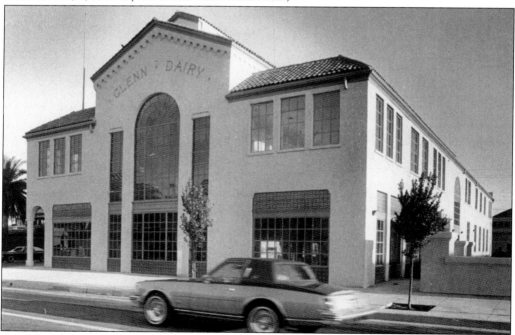

Owned and operated by Edwin Betschart and C. P. Inderkum, the highly modern Glenn Dairy opened on November 29, 1924. It was seen as another triumph of Sacramento's industrial power. Built at a cost of $120,000, the two-and-a-half-story milk and cream processing plant was an impressive sight at the southwest corner of Alhambra and Q Streets. In this photograph from August 1984, the building has been remodeled for commercial space. (Courtesy *Sacramento Bee* Collection.)

Four

CAPITOL CORRIDOR
L, M, AND N STREETS
BY PATRICIA J. JOHNSON

Streetcars and the electrification of the city helped to precipitate the eastward expansion of Sacramento. These streetcars and electric trolleys allowed families to move out from the crowded central business district and into, what was in the 19th century, "wide-open space." Today it has all the elements of a thriving neighborhood that identifies itself as "Midtown." To help promote its identification, Midtown businesses, neighborhood associations, and cultural groups now sponsor community and cultural events in the district.

The corridor along L, M, and N Streets from Sixteenth to Thirty-first Streets supported Victorian mansions, Craftsman bungalows, and a variety of businesses and manufacturers. Among these were neighborhood markets, a fire station, and later a hospital. At the end of L Street stood a pottery works that dated from 1878 but was removed to make room for the north-south freeway (Capital City Freeway) in 1964.

M Street, or Capitol Avenue, is an extra-wide boulevard and a centerpiece of Midtown. A major entrance from the west over the Tower Bridge, into the city, and leading to the state capitol, the Sacramento Junior Chamber of Commerce proposed to the city council the name change from M Street to Capitol Avenue as a beautification project. The council passed an ordinance in 1940 changing the name. M Street was home to some prominent Sacramentans such as Hiram Johnson and Henry August Heilbron. Just as a manufacturer operated a business at the end of L Street in the 19th century, so too was M Street home to another large operation—a brewery.

Not to be outdone, N Street also supported a phalanx of markets, homes, and businesses, including a home converted to a bed-and-breakfast, an Irish pub, a feed store, and the home of streetcar garages. All along the eastern and southern boundary of Midtown, businesses found space to stretch out and accommodate their needs.

The capitol corridor is an important connection in defining the culture of the neighborhood, which includes Capitol Avenue and the Winn Park Capitol Avenue Neighborhood Association.

Typical of a Midtown neighborhood restaurant, Juliana's Kitchen, serving Mediterranean cuisine, occupied the first floor while the second story was for private residences. Built in 1909 at the corner of Eighteenth and L Streets by the Keema family, the bottom floor of the building was used commercially by grocers, butchers, and bakers. In the 1970s, the building was remodeled for restaurant use. (Courtesy *Suttertown News* Collection.)

"Harv's Corner" car wash was more than just a place to get your car cleaned. Owner Harv Miller claimed the Nineteenth and L Street operation was a place for local people to gather. People could get their cars washed, do a little gift shopping, pick up essentials, and have a quick bite at Harv's lunch counter all at the same time. (Courtesy *Sacramento Bee* Collection.)

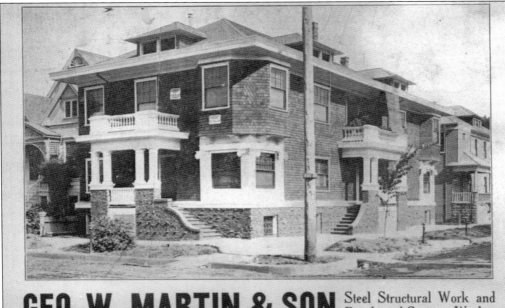

Early in the 20th century, the neighborhood began supporting more examples of an eclectic style, incorporating both Greek Revival and Craftsman-style architecture. George W. Martin and Son built this impressive structure as a testament to their skills as builders. They used it in an advertisement in the 1913 city directory. While the streets were still unpaved, note that the concrete curbs were in place and the hitching posts remained intact. (Courtesy Retail Credit Association Collection.)

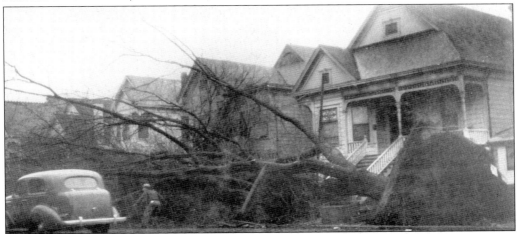

As the City of Trees, Sacramento streets can be hazardous at times as this scene on the north side of L Street between Twentieth and Twenty-first illustrates. On February 9, 1938, Sacramento experienced the "windstorm of the century," which felled about 1,000 elm trees. One person was killed and about 40 people were reported injured. People were without power for several days. Traffic was at a standstill; even the streetcar service was off-line. (Courtesy Eugene Hepting Collection.)

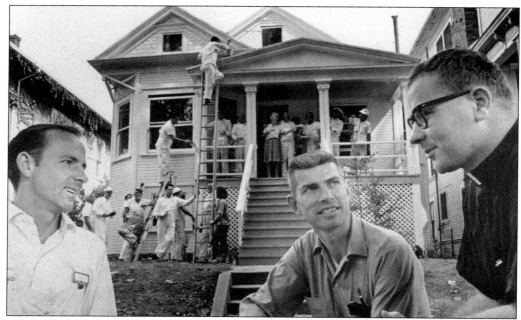

Originally built in 1905 for John Tofft, a local restaurant owner, this house at 2525 L Street underwent renovations in 1967. It became the Religious Center for Deaf and Hard of Hearing sponsored by the Catholic Church of Sacramento. Pitching in to help, from left to right, are Tom Caster, Painters Union Local No. 487; Gene West, Knights of Columbus; and Fr. Colm O'Kelly of the Sacramento Diocese. (Courtesy *Sacramento Bee* Collection.)

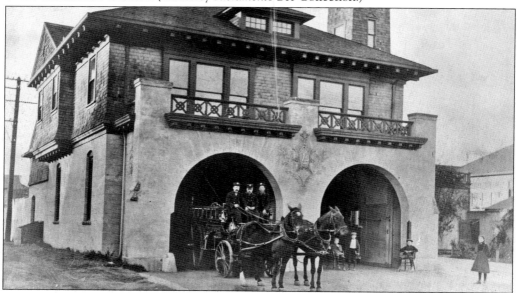

Fire Engine Company No. 4 on Twenty-sixth Street between L and M Streets was put into service on March 1, 1902, at a cost of $12,000. The fire truck and other apparatus cost $5,500. In this c. 1905 view, three firemen are driving the fire wagon out of the building. The firehouse was remodeled into a multiple-family home in 1934 by John Groth. Today the 1214 Twenty-sixth Street house is an apartment building. (Courtesy Sacramento Valley Photographic Survey Collection.)

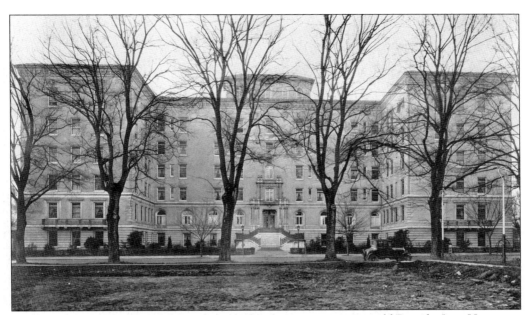

On December 3, 1923, Sutter Hospital received its first patient, six-year-old Dorothy June Humason. The state-of-the-art building, at Twenty-eighth and L Streets, cost $650,000 to construct. It was a 100-bed facility and has undergone numerous additions and renovations in the 83 years since its construction. A major change occurred in 1983 when Sutter began building a new 299-bed hospital across the street. (Courtesy Ralph Shaw Collection.)

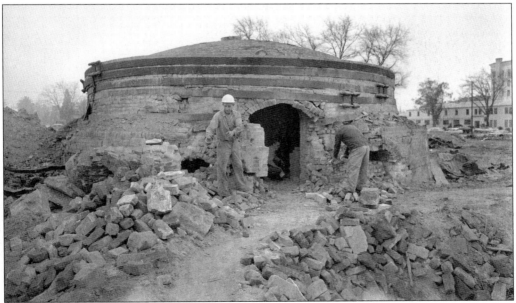

A manufacturer of clay products, H. C. Muddox Company, located at Thirtieth and L Streets, was in the path of progress in 1964. Pictured here is the last of the Muddox kilns to be razed to make way for the north-south freeway. Established in 1878, the office and factory occupied a three-story building that covered the whole block. With the construction of the freeway, Muddox moved the operation to the southern part of Sacramento County. (Courtesy *Sacramento Bee* Collection.)

The East End Cash Store was at the corner of Eighteenth and M Streets in 1884 in an area of Sacramento known as the "East End." The George Lichthardt family lived above the store. By 1900, Lichthardt and his son changed the grocery into a pharmacy. Today that end of Capitol Park is still referred to as the East End and now supports many new office buildings and condominiums. (Courtesy City of Sacramento Collection.)

This view looks east along Capitol Avenue on the 1900 block as it appeared in 1950. Midtown is a mix of businesses and residences. The *Sacramento Union* newspaper office at 1910–1914 is pictured on the right. Note the wide boulevard, with enough room for two lanes of cars in both directions and parking on both sides of the street. This wide boulevard is the centerpiece of Sacramento. (Courtesy Ernest Myers Collection.)

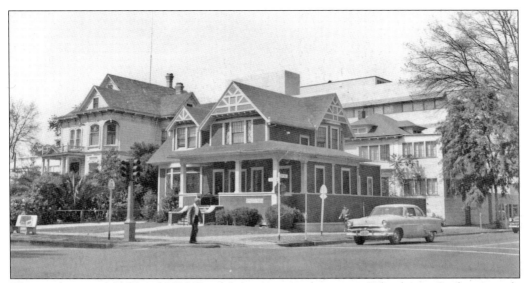

The two houses at 2025 and 2029 Capitol Avenue were luxurious and spacious Craftsman-style homes built by prominent Sacramentans. The Heilbron House, on the left, built by Henry A. Heilbron, was owned by a family of successful businessmen. The house on the right was built by Dr. C. L. Megowan as a residence and remodeled in 1946 to become the offices of Drs. Schofield and Schwing. (Courtesy Eugene Hepting Collection.)

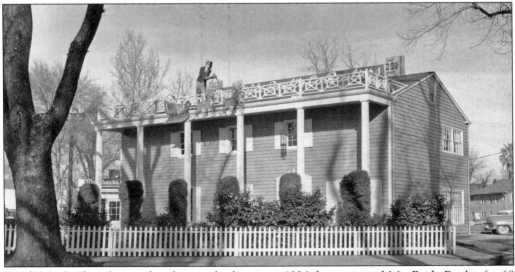

Frank MacBride, a licensed real estate broker since 1936, has operated MacBride Realty for 68 years in the Sacramento region. His office was in Midtown at 2101 Capitol Avenue for more than 30 years before moving to its present location on Fair Oaks Boulevard. Pictured here, c. 1965, the neon sign that once sat atop the Colonial-style office is now in the archives at SAMCC. (Courtesy *Sacramento Bee* Collection.)

Owned by the founder of the Save the Redwoods League, Dr. William Briggs, this Colonial Revival–style home at 2209 Capitol Avenue was built in 1901 and became a bed-and-breakfast known as the Briggs House in 1983. According to the present owners, they maintained many of the features of the original house when converting the home to a bed-and-breakfast. (Courtesy *Sacramento Bee* Collection.)

Former U.S. senator and California governor, Hiram Johnson lived at 2431 M Street in 1900. This is a 1936 view of the home. Johnson, born in Sacramento in 1866, would go on to become a prominent lawyer and politician. He was elected governor in 1910 as a Progressive Republican and after serving as governor, was elected to the U.S. Senate in 1916, serving until 1940. (Courtesy Eugene Hepting Collection.)

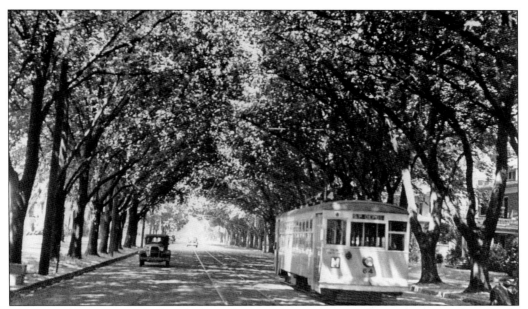

This view along M Street looks west from about Twenty-sixth Street during the 1930s when Pacific Gas and Electric ran a trolley system in Sacramento. The elm trees, for which Sacramento is noted, provided a shaded canopy over the street. This idyllic scene is no longer as prevalent today due to redevelopment as well as age and the occurrence of disease found in the trees. (Courtesy Sacramento Metropolitan Chamber of Commerce Collection.)

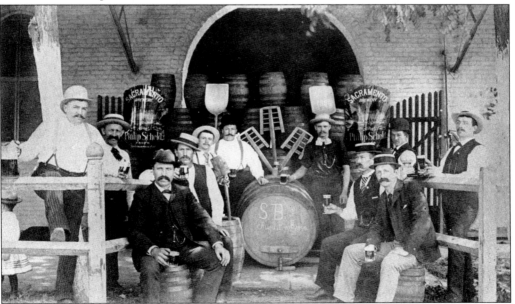

Brewers and employees pose for this photograph at the Sacramento Brewery on Twenty-eighth and M Streets, c. 1890. Established in 1849 by Peter Kadell, who then sold it to Philip Scheld in 1854, the brewery continued to operate well into the 20th century. The original building was replaced in the 1870s when Philip Scheld hired M. Madden to construct a substantial two-story brick structure on the site. (Courtesy *Sacramento Bee* Collection.)

Employees of the Sacramento Brewery enjoy the outdoors in this 1900–era view of the brewery. Occupying two lots at Twenty-eighth and M streets, this view also shows the brick additions that were added in the 1870s. The brewery served as a warehouse until the 1920s when it was remodeled and became known as the Old Tavern Building, pictured here. (Courtesy Sacramento Valley Photographic Survey Collection.)

By the 1920s, the brewery building had been converted to other commercial uses, including a tavern on the first floor and residential apartments on the second floor. The Old Tavern boasted that the original back bar used in the brewery in 1853 was still in use into the 1940s. Owned today by Sutter Health, the building was placed on the National Register of Historic Places in 1983. (Courtesy Anne Ofsink Collection.)

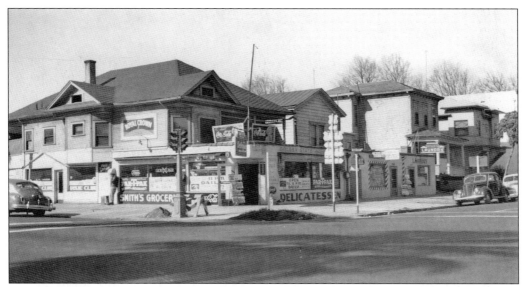

Neighborhood markets are a fixture in Midtown. This view of the southwest corner of Sixteenth and N Streets showing Smith's Groceries and Willie's Laundry is typical of corners in urban neighborhoods throughout America. Shopkeepers often lived above the store. A few people in the 1950s did not have private telephones in their homes. Note the gentleman using the pay telephone to the left of the store. (Courtesy Eugene Hepting Collection.)

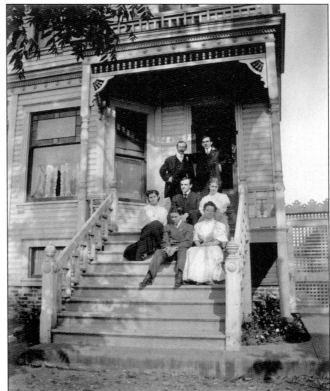

The Waldau house at 1417 Twenty-second Street, near N Street, was a family home for members of David Joslyn's family. Posing for their photograph, the family members participated in a theatrical production of *Between the Acts*. Pictured here, from left to right, are (first row) George Clark and Kitty Waldau; (second row) Evelyn Waldau, J. Hinman, and Edith Waldau; (third row) John Klees and David L. Joslyn. (Courtesy Joslyn Family Collection.)

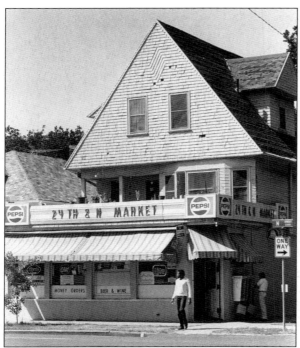

More than 25 years later, neighborhood markets are still a fixture in Midtown. Again note the gentleman on the phone; cell phones, phenomena of the future, would eventually replace most pay phones. The Twenty-fourth and N Street Market is a magnet for local residents. By the 1970s, many of the streets in Sacramento were designated "one way" to help alleviate traffic congestion in the downtown and Midtown area. (Courtesy *Sacramento Bee* Collection.)

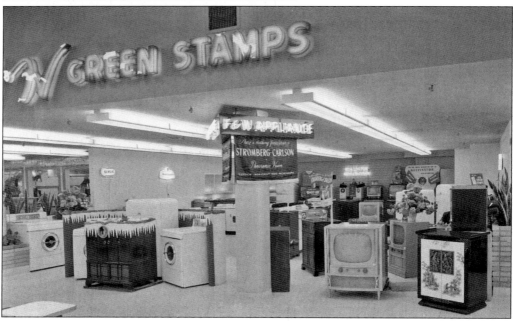

F and W Appliance, at 1423 Twenty-eighth Street and N Street, provided the neighborhood with the latest televisions, washing machines, and refrigerators popular in 1953. Decorated for the Christmas season, the appliance store even offered S&H Green Stamps to their customers. The green stamp promotional program enabled people to collect stamp books redeemable for consumer goods. *Sacramento Bee* photographer Harlin Smith captured this scene. (Courtesy *Sacramento Bee* Collection.)

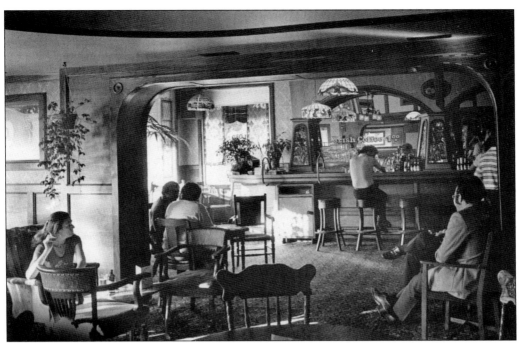

The restaurant Lord Beaverbrooks, located at the corner of Twenty-eighth and N Streets, was a favorite watering hole for the neighborhood. It boasted a "homey atmosphere" in the 1980s, reminding patrons of an English or Irish pub. The interior featured paintings on the ceiling, stained-glass windows, and a very clever "open" sign in the form of a rebus puzzle. (Courtesy *Sacramento Bee* Collection.)

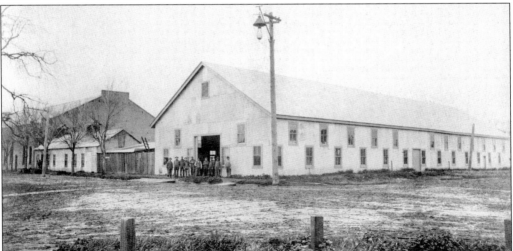

Employees of the Sacramento Gas and Electric Railway Company pose here in 1903 at the back of their building on Twenty-ninth and N Streets. The carbarns that housed the streetcars encompassed the entire block bounded by Twenty-eighth, Twenty-ninth, M, and N Streets. Electric trolley service in Sacramento began in 1890 and continued operation until 1947. Albert Gallatin, the original owner of the Governor's Mansion, was a major partner in starting the streetcar company. (Courtesy William Sommers Collection.)

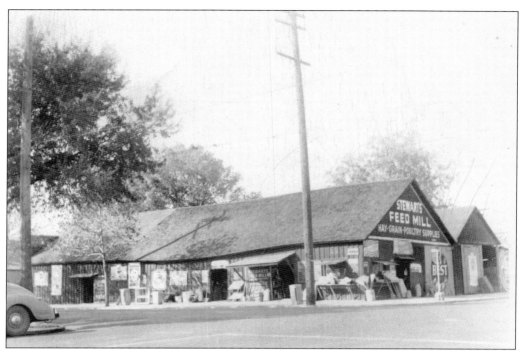

James E. Stewart opened Stewart's Feed Mill in 1906 on the southwest corner of Thirty-first and N Streets. A hay, grain, and poultry supply business, Stewart's was on the corner for more than 50 years. The family lived nearby at 1414 Thirty-first Street. This 1940s–era photograph shows the many types of dry goods the store sold. Maps from 1915 even show a barley mill on the premises. (Courtesy Birdie Boyles Collection.)

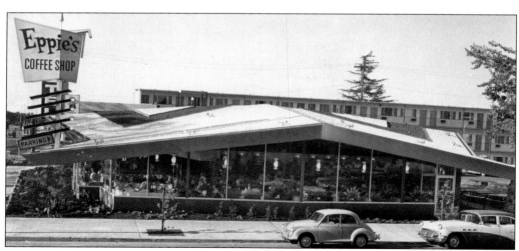

Eppie's Restaurant and Coffee Shop opened on Thirtieth and N Streets in June 1964 in the midst of two new hotels. A $285,000 structure, the popular eatery, with its folded roof design, was the innovation of owner and Sacramento caterer Eppie Johnson. A former Midtown landmark, Eppie's underwent a major remodeling in the 1980s after a fire gutted the restaurant. (Courtesy *Sacramento Bee* Collection.)

Five

R STREET CORRIDOR
INDUSTRY ON THE GO
BY CARSON HENDRICKS

R Street began life as the de facto southern edge of the city, even though it was well inside city limits. Originally a levee was built along the street to keep water out. Most of the numbered streets did not go south beyond R Street. Eventually the Sacramento Valley Railroad (the first railroad west of the Mississippi River) was built atop the levee. The levee turned north at Nineteenth Street toward the American River, but the SVRR built an embankment to continue the line over the swampy ground. The SVRR was bought by Southern Pacific in 1865, and the line continued but not as a main line.

The first business to operate on R Street above Fifteenth Street was the Buffalo Brewery in 1888, followed by the California Winery in 1890. The city removed the levee in 1903 and Southern Pacific put down new tracks. The city made it a policy to develop R Street as an industrial area. This was possible because spur lines could be easily built off the SP line. The needs of business were put above the needs of residents, who worried about the safety of pedestrians and traffic at the grade crossings.

By 1930, over 40 businesses had opened on the R Street corridor from Front Street to Thirty-first Street. R Street was the center of a large transportation network that encompassed railroads, water, and trucking, the result being that distribution companies and their warehouses sprang up on the corridor. In 1925, Southern Pacific built six spur tracks in the three blocks between Twenty-third and Twenty-fifth Streets. Also that year, Sacramento was the second busiest river port in the nation, with one and a half million tons of freight passing through.

Eventually however, the growth in population and traffic overwhelmed the area. Residents complained about the delays in crossing R Street due to the constant switching of railcars. Upgrading grade crossings was too expensive, and by 1983, Southern Pacific had closed the R Street line. The current hope is to redevelop R Street into residential and commercial uses, while attempting to retain the industrial look of the corridor.

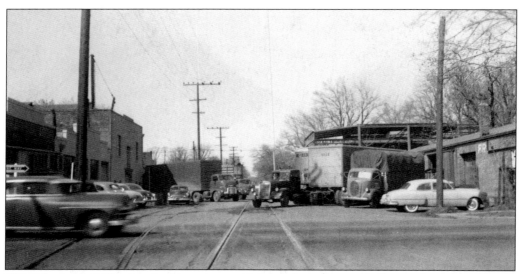

This March 14, 1953, view, looking west on R Street from Sixteenth Street, shows how busy R Street could be at times. Visible in this photograph was the Mission Fuel and Feed Company on the left and the Sacramento Planing Mill and Palm Iron Works on the right. The tracks for the Southern Pacific ran down the center of the street. (Courtesy Eugene Hepting Collection.)

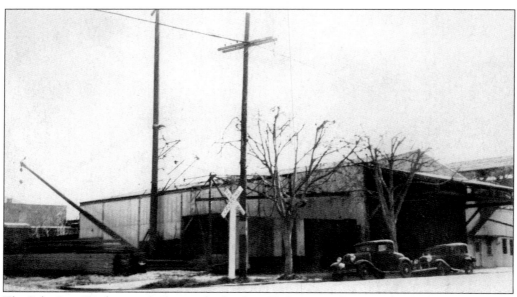

The Palm Iron Works stretched across both sides of R Street on the east side of Fifteenth Street. It was located here from 1903 until the 1980s. Palm Iron started as a blacksmith shop and eventually became a major supplier of iron beams for large construction projects in Northern California. The plant eventually moved out of Midtown, settling along Highway 50 near Rancho Cordova. (Courtesy Eugene Hepting Collection.)

The iron works closed its R Street operation in the early 1980s. The structures were demolished, as seen in this photograph from January 5, 1983. The project was undertaken as part of a larger plan to bring new development to R Street and move it away from being an industrial center to an area with housing and shopping. (Courtesy *Sacramento Bee* Collection.)

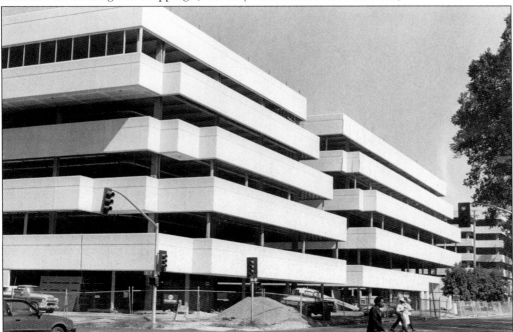

The site of the old foundry was redeveloped in 1986 by Joseph Benvenuti. The new building took up the entire block on the south side of R Street between Fifteenth and Sixteenth Streets. Light Rail trains run up R Street and the new development, The Plaza, was built to take advantage of it. The site contains state government offices and parking garages. (Courtesy *Sacramento Bee* Collection.)

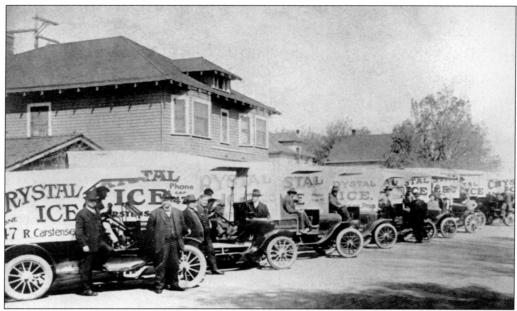

Originally known as Carstensen's Crystal Ice, the Crystal Ice Company operated on R Street between Sixteenth and Seventeenth Streets from 1920 until the mid-1980s. Pictured here are at least 10 delivery vehicles. Before refrigerators became widely available, most people had iceboxes to keep foods fresh, requiring that ice be replenished every few days. There were several ice companies in the city, with Crystal being one of the largest. (Courtesy *Sacramento Bee* Collection.)

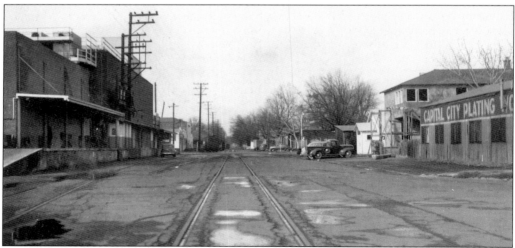

The Crystal Ice Company is pictured on the left in this image looking west from Seventeenth Street in 1950. The company moved further up R Street to Eighteenth Street in the mid-1980s. Across the tracks, to the right of the photograph, is Capital City Plating Works and Christ Temple Pentecostal Church. Prior to Crystal Ice, the block was the home of Capital City Casket in 1915. (Courtesy Eugene Hepting Collection.)

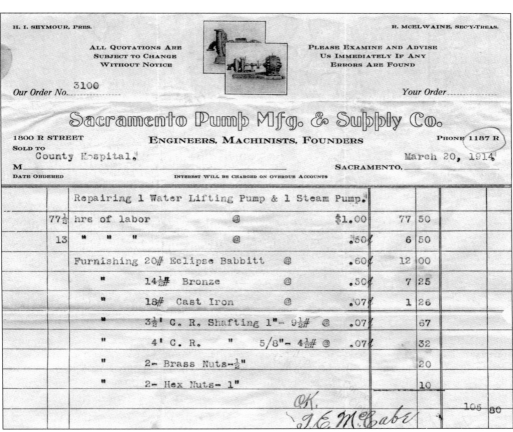

H. I. SEYMOUR, PRES. R. McELWAINE, SEC'Y-TREAS.

ALL QUOTATIONS ARE
SUBJECT TO CHANGE
WITHOUT NOTICE

PLEASE EXAMINE AND ADVISE
US IMMEDIATELY IF ANY
ERRORS ARE FOUND

Our Order No. 3100 Your Order

Sacramento Pump Mfg. & Supply Co.

1800 R STREET ENGINEERS, MACHINISTS, FOUNDERS PHONE 1187 R

SOLD TO
County Hospital, March 20, 1914

M SACRAMENTO,

DATE ORDERED INTEREST WILL BE CHARGED ON OVERDUE ACCOUNTS

		Repairing 1 Water Lifting Pump & 1 Steam Pump.					
	77½	hrs of labor @	$1.00	77	50		
	13	" " " @	.50¢	6	50		
		Furnishing 20# Eclipse Babbitt @	.60¢	12	00		
		" 14¼# Bronze @	.50¢	7	25		
		" 18# Cast Iron @	.07¢	1	26		
		" 3½' C. R. Shafting 1"- 9½# @ .07¢			67		
		" 4' C. R. " 5/8"- 4¼# @ .07¢			32		
		" 2- Brass Nuts-½"			20		
		" 2- Hex Nuts- 1"			10		
		OK. J.E. McCabe		105	80		

Sacramento Pump Manufacturing and Supply Company operated at 1800 R Street in 1914. This billing invoice was for repair work at the county hospital on Stockton Boulevard. Many businesses along R Street had contracts with both the city and county. Rogers and D'Artnay Manufacturing, a blacksmith shop, was at this address in 1910. In 1938, the corner was occupied by Pacific Iron and Metal Company. (Courtesy City of Sacramento Collection.)

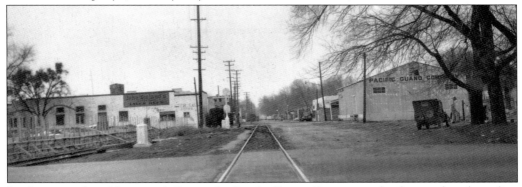

Looking west from Nineteenth Street, the Pacific Guano Company, a fertilizer and seed supplier, is pictured on the right in January 1950. Also located near here was the Feather River Water Bottling Company at 1825 R Street. This stretch of R Street was home to mostly warehouses, including one taking up a half block and owned by the Arata Brothers, a local grocery supplier. (Courtesy Eugene Hepting Collection.)

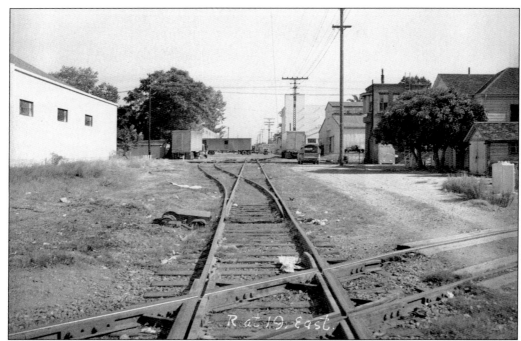

Looking east from Nineteenth Street, this view shows the crossing points for the Southern Pacific and Western Pacific Railroads. Landsberg Lumber was located to the left. That warehouse is still operating as Capital Rubber Company. At the right is the house for the WP switchman and the signal tower. Beyond that is a warehouse for the U.S. government. (Courtesy Ernest Myers Collection.)

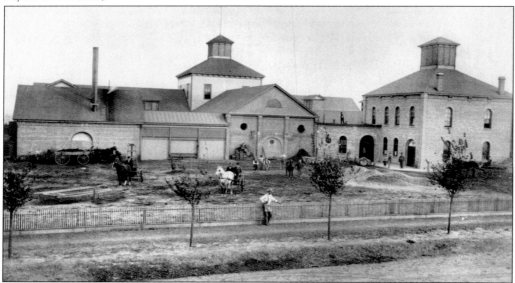

The California Winery was built in 1890 by Manuel Nevis and took up the entire block bounded by Twenty-first, Twenty-second, R, and S Streets. The winery operated until 1926, when Prohibition forced its closure. In 1898, Nevis built a Queen Anne–style home at 1822 S Street that still stands today. (Courtesy Barbara Bennett-Kelly Collection.)

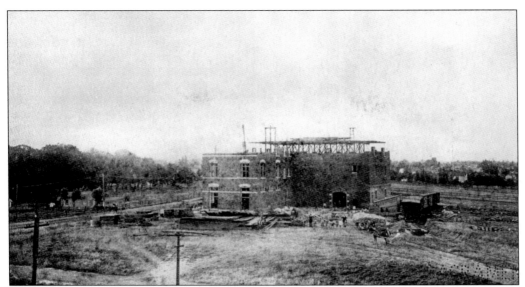

The Buffalo Brewing Company is pictured here under construction in 1889. The brewery was founded by Herman H. Grau of Buffalo, New York. In August 1890, August Heilbron and Frank Ruhstaller were the president and vice president, respectively. When built, the brewery had a capacity of making 60,000 barrels of beer a day. (Courtesy Eugene Hepting Collection.)

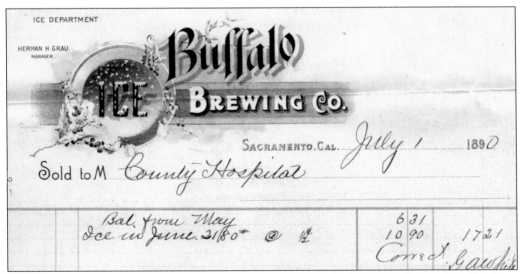

The brewery also made ice. The company had a contract with the county hospital on Stockton Boulevard to supply ice. The hospital used 2,180 pounds in the month of June in 1890. Ice was used in the brewing process, and at the time, Buffalo was the largest supplier of ice in the area. These receipts from the county were discovered in 1977 in the basement of the Sacramento County Courthouse. (Courtesy City of Sacramento Collection.)

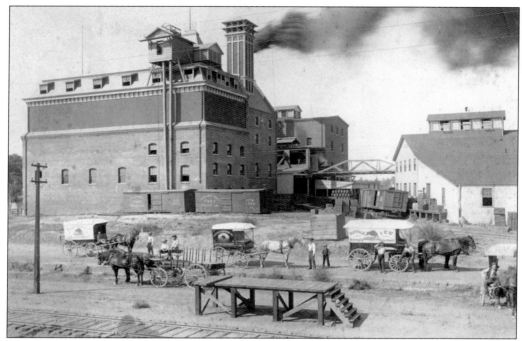

This image shows the Buffalo Brewery in full operation. This is half of a panoramic photograph that shows the entire complex from R Street, *c.* 1900. Next to the main building are two Southern Pacific freight cars on a spur line along with a small loading platform next to the main track. The wagons were painted by Bowman's Paint shop at 918 J Street. (Courtesy *Sacramento Bee* Collection.)

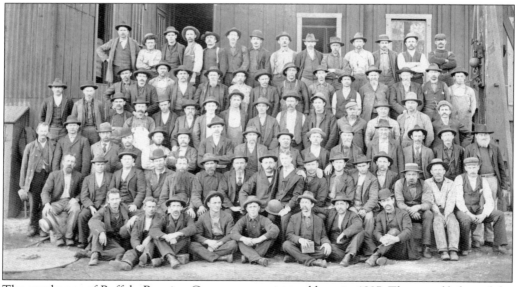

The employees of Buffalo Brewing Company are pictured here in 1897. The grandfather of the donor of the photograph, Martin Alber, is in the group but is not specifically identified. At the height of its business, Buffalo covered the block bounded by Twenty-first, Twenty-second, Q, and R Streets and employed over 80 people. (Courtesy Richard Vincent Collection.)

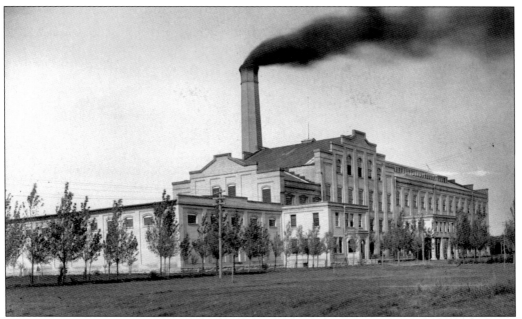

This glass-plate negative is undated but was probably taken in the mid-1890s. It shows the front of the Buffalo Brewing building facing Twenty-first Street. The company closed from 1929 until 1933 because of Prohibition. After reopening, the brewery was not as successful as it previously had been, and after a series of owners, it closed permanently in 1942. (Courtesy Sacramento Trust for Historic Preservation Collection.)

Hammering It Into His Head

That the Buffalo Brewing Company's Lager Beer is the best brewed isn't necassary at all. You will find that every man, of either business or pleasure, knows it.

Honest hops, pure water, brewers who know their business and great care in every step of manufacturing—that's the story in a nutshell.

The Buffalo Brewing Co.

This advertisement for Buffalo Brewing Company appeared in *Figaro*, the publication for the Clunie Theatre, in 1903. While its exact meaning to a modern audience remains elusive, the advertisement was clearly an effort by the company to stand out in the competitive Sacramento brewing business. In addition to several national breweries, there were three local beer makers at the time. (Courtesy Eleanor McClatchy Collection.)

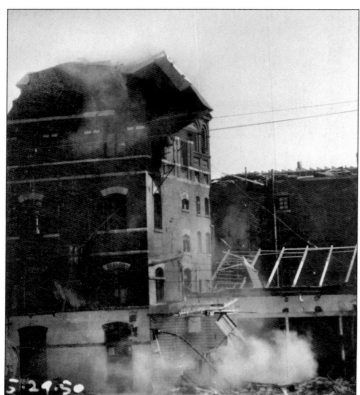

The property, owned by Buffalo Brewing, was purchased by the *Sacramento Bee*, which in 1950 demolished the structures. Due to unprecedented growth at the newspaper, their former home on Seventh Street was no longer practical. This photograph from May 29, 1950, shows a portion of the tower roof falling during the demolition process. (Courtesy Eleanor McClatchy Collection.)

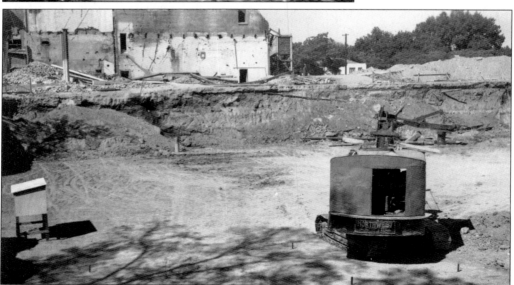

Construction for the new *Sacramento Bee* building began by August 1950. This photograph shows the basement being excavated. Part of the Buffalo Brewery is still standing in the background, most likely the Twenty-first Street facade. The building under construction would house the paper's new presses and satisfy its need for additional office space. (Courtesy Eugene Hepting Collection.)

The new building at Twenty-first and Q Streets was in the early stages of construction in 1950. The first paper off the new presses was dated April 14, 1952. The building housed the business offices, editorial offices, and the printing plant. Today it is still the headquarters of the company. The *Bee* took advantage of the rail spur that was used by Buffalo Brewery. (Courtesy Eleanor McClatchy Collection.)

This photograph shows an unidentified "worker bee" unloading rolls of paper from a railcar on the loading dock of the new Sacramento Bee Building. He is using a specially adapted forklift. The image was taken *c.* 1952, not long after the building opened. The structure was designed to meet not only the company's immediate needs, but also for future expansion, which happened in the 1980s. (Courtesy *Sacramento Bee* Collection.)

Across Twenty-first Street from the *Sacramento Bee* was the Bekins Van and Storage Company warehouse. Built in the 1920, the all-concrete structure was highly touted as the most modern fireproof building in Sacramento. The structure was eventually purchased by the *Sacramento Bee*, much later in the century, and today it is a self-storage facility. This image was taken on April 15, 1955. (Courtesy Frank Christy Collection.)

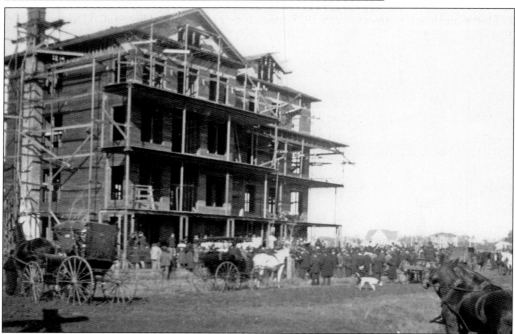

The Sisters of Mercy purchased the Ridge Home, a 15-bed sanitarium at Twenty-second and R Streets in 1895. In 1896, they began construction of a 30-bed hospital. This photograph shows a large crowd gathered for an unknown ceremony, probably in 1896 while the hospital was still being built. The new hospital was named Mater Misericordiae (Latin for "Mother of Mercy"). (Courtesy Dick Collin Collection.)

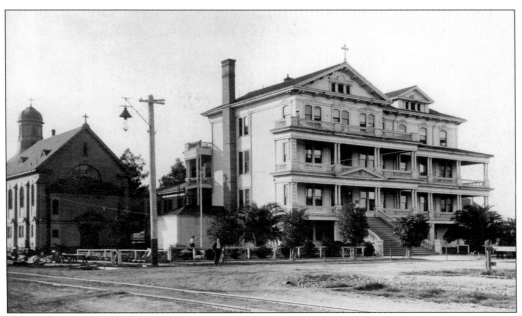

By around 1907, when this image was taken, Mater Misericordiae had expanded considerably. When an influenza epidemic hit Sacramento in 1918, the hospital had 90 beds and covered most of the block at Twenty-second and R Streets. The next year, the sisters purchased the site at Thirty-ninth and J Streets and in 1925 opened their new 155-bed hospital. (Courtesy Robert Tutt Collection.)

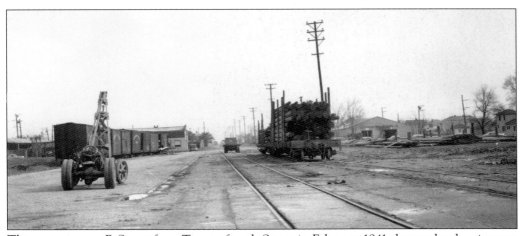

This east view on R Street from Twenty-fourth Street in February 1941 shows why the city was, and is, so keen on redevelopment for the corridor. The railcar to the right was loaded with power poles for Pacific Gas and Electric, with more poles lying on the far right. In the right background was Sacramento Rock and Gravel. This scene is virtually unchanged today. (Courtesy Eugene Hepting Collection.)

The Diamond Match Company operated on both sides of R Street between Twenty-eighth and Twenty-ninth Streets. Despite the name, they specialized in building materials for contractors and had numerous lumber sheds and a large lumber storage yard. On July 10, 1972, Diamond National Corporation (as the company was then known) suffered a devastating fire. Sacramento County offices now occupy the site. (Courtesy *Sacramento Bee* Collection.)

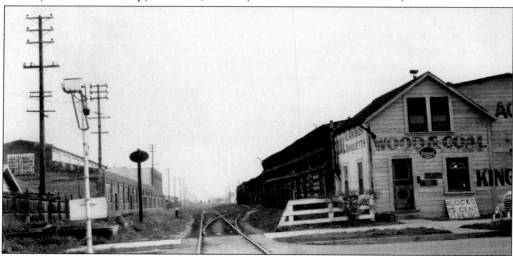

The original city limits are at Thirty-first (Alhambra Boulevard) and R Streets. On the right is the Acme Fuel Company, which sold coal, wood, fertilizer, and Pres-to-logs. Fire was a relatively common occurrence along R Street, and in 1945, Acme Fuel was destroyed by fire. To the left is Libby, McNeil, and Libby's cannery. The building was listed on the National Register of Historic Places in 1982. (Courtesy Eugene Hepting Collection.)

Six

POVERTY RIDGE CORRIDOR

O STREET THROUGH BROADWAY

BY SHAWN SCARBOROUGH

The Poverty Ridge corridor includes the neighborhoods of Fremont Park/Richmond Grove, Newton Booth, and Poverty Ridge. The boundaries are from O Street to Broadway and from Fifteenth Street to Alhambra Boulevard (Thirty-first Street). Poverty Ridge is so named because it was high ground where people went for safety during the numerous floods of the 1800s, and everyone looked so poor camped on the hillside. Beginning in the late 1800s, developers started building large homes and mansions for more affluent members of the community, most of which are still standing. The developers attempted to rename the area "Sutter's Terrace," but it never caught on, as Sacramentans appreciated the irony of the name "Poverty Ridge."

The Newton Booth district is named after California's 11th governor, Newton Booth, and the school, built in 1915, was named for him. Quite a large part of the area was built after World War II, as it was the last remaining portion of the original city left undeveloped. The area had been skipped over when Oak Park was developed in the 1890s. Housing styles in the area were influenced by architecture popular on the East Coast of the U.S. and were most often composites of two or more styles.

The area also includes Winn Park, at Twenty-seventh and P Streets, and Fremont Park, located at Fifteenth and P Streets. These parks were part of the original layout of the city by John Sutter Jr. Fremont Park was named for the well-known western explorer, John C. Fremont. Winn Park was named for Mayor A. M. Winn, the city's second mayor after William Stout, who served only three weeks in 1849. The corridor also includes the industrial district of R Street, which was covered in the previous chapter. Outside a few small grocers and other businesses, the area was and is mostly residential. It is important to note that the outer edge of the neighborhood was leveled for the construction of the current interstate, Business 80 (Capital City Freeway), and Highway 50 in the early 1960s.

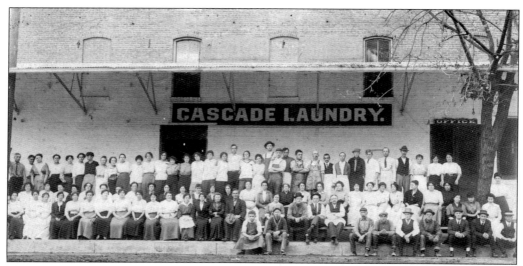

This group photograph was taken c. 1900 of the Cascade Laundry Company staff at their 1515 Twentieth Street location. Most of the 94 people in the photograph are identified. The laundry was very successful in serving not only the Poverty Ridge corridor residents, but also nearby Sacramento hotels and restaurants. Cascade merged with another laundry service, Mason's Steam Laundry, in 1940 and employed a large workforce. (Courtesy Bette Robinson Collection.)

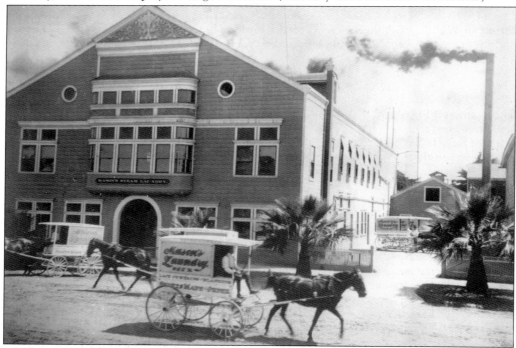

Mason's Steam Laundry plant was located at 2030 O Street at Twenty-first Street. Their retail outlet was downtown on K Street. In this c. 1898 view, horse-drawn wagons are making deliveries to the plant. The building was first used as swimming baths and operated from 1892 until 1897 when Fred Mason took over and converted it into the laundry. Mason's widow continued to operate the laundry into the 1940s. (Courtesy Eugene Hepting Collection.)

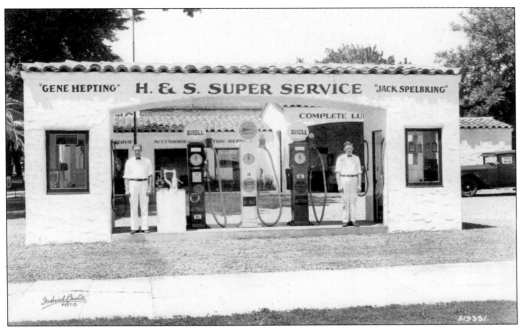

Pictured here in their starched, white uniforms, Eugene Hepting and his partner, Jack Spelbring, operate H and S Super Service Shell gas station at the northwest corner of Twenty-first and O Streets in 1932. In 1910, there were 45 service businesses associated with horses; by 1920, they had all been replaced with automobile-related businesses. Note the price of gas in 1932 was 21.5¢ for premium. (Courtesy Eugene Hepting Collection.)

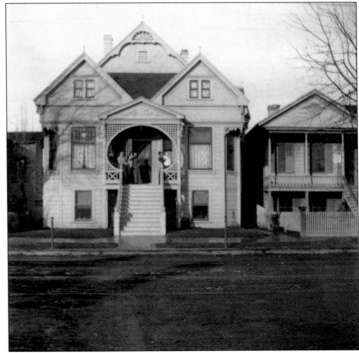

The Thomas P. Fraser family poses on the porch of their 1625 P Street home in this c. 1890 photograph. The Frasers were related to the Schroth and Beauchamp families, who owned the Phoenix Flour Milling Company in Sacramento. All three families were prominent Sacramentans. Thomas P. Fraser served as a California state senator. The residence has Queen Anne–architectural elements seen in the lattice work framing the porch and the gingerbread along the roofline. (Courtesy Frederick Beauchamp Collection.)

Fehr's Mayonnaise Company opened in 1934 in its new, larger location at 1615 Twenty-first Street. In operation since 1925, the new manufacturing facility offered expanded quarters and more room for better equipment. The sign on the side of the building reads, "Home of Fehr's Mayonnaise." In this c. 1940s photograph, Fehr's advocated weight loss by eating "Min-Rel-Aise," a slenderizing, non-fattening dressing, well ahead of the non-fat foods of today. (Courtesy City of Sacramento Collection.)

Just as popular today, farmer's markets were a convenience in the neighborhood in the 1970s. Pictured here on July 22, 1973, is the Farmers Free Market at Twenty-ninth and P Streets. Vendors are seen serving their customers a variety of fruits, vegetables, and other wares. Note that the unidentified woman on the far left appears to be negotiating for the "fresh large grade A eggs," selling for 80¢ a dozen. (Courtesy *Sacramento Bee* Collection.)

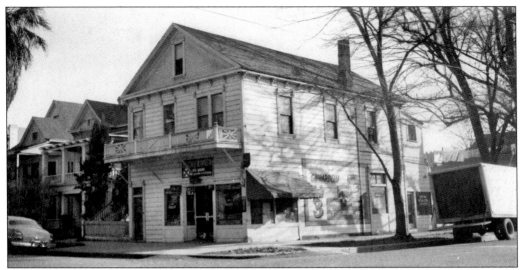

The Fremont Grocery, located at 1500 Q Street, was owned by the Manuel I. Enos family in 1899. Manuel immigrated to the United States from the Azores in 1872. He operated the grocery store with his two daughters and two sons until his retirement in 1912. His son Alfred N. Enos continued to run the store until 1933. The property remained in the family well past 1951 when this photograph was taken. (Courtesy Eugene Hepting Collection.)

In June 1982, when property owner Ritz Naygrow wanted to tear down his brick building at 1910 Q Street, the Sacramento Preservation Board objected on the grounds that the building was "representative of a widely popular architectural style." Naygrow protested, "it's a wreck . . . it's not historical, it's hysterical." Nevertheless the building remained. Constructed in 1914 for the California Expert Cleaners and Dyers Company, the architectural style was unusual for industrial buildings. (Courtesy *Sacramento Bee* Collection.)

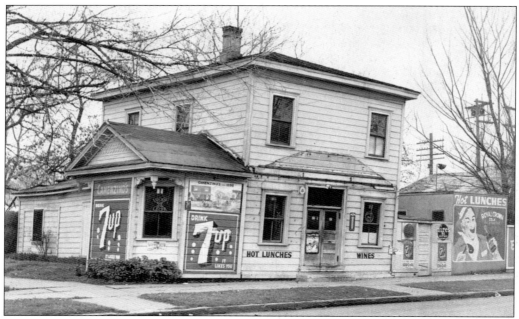

Camenzind's Saloon, located on the northeast corner of Twentieth and Q Streets, started in 1898 as the Richmond Grove Saloon and Bowling Alley. By the mid-1930s, Charles Camenzind was listed as a soft-drink retailer, indicated by the ads for Royal Crown Cola, 7-Up, and Hires Root Beer. This site was formerly the Richmond Grove Park. The photograph was taken in 1951. (Courtesy Ralph Shaw Collection.)

The simple Folk Victorian residence at Nineteenth and S Streets was the home of the Grebitus family. Edwin Grebitus Sr. founded the family jewelry business, Grebitus and Sons, in 1926. Before that, Edwin was employed as a blacksmith. This home was built by Wallace Doan, an agent for the *San Francisco Chronicle*, in 1892 and purchased by the Grebitus family in 1904. (Courtesy Eugene Hepting Collection.)

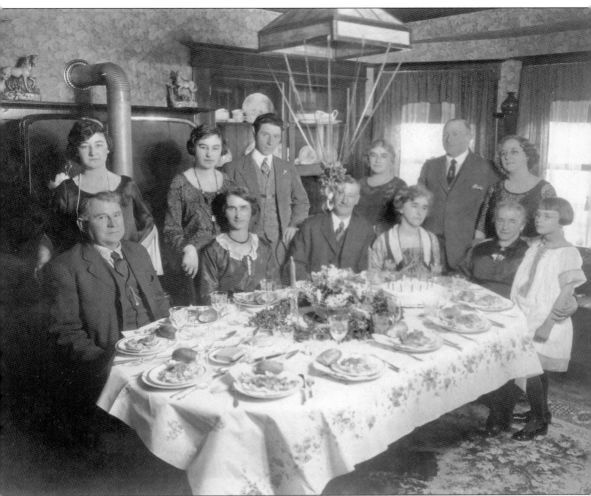

Whether they came in search of gold, a job with the railroad, or to be reunited with family and friends, Sacramento provided a home to a large diversity of people and, as a result, offers a rich heritage. Maria Garbarina (seated, far right) emigrated from Italy to the United States in 1882, accompanied by her two older daughters, Jennie and Theresa. They were reunited with their father, Joseph, who had preceded them six years earlier, and later two more daughters were born into the family. Here the family gathers in March 1923 for Maria's 70th birthday at the home of John and Annie DeStasio (standing, far right) at 2016 Twenty-eighth Street. The family found success in Sacramento as Pete and Jennie Lambardi (seated, third and fourth from right) and Adam and Theresa Neumann (seated, far left) were both Southern Pacific families, with their husbands each working in the shops; the DeStasio's ran the Lyric Theater on Sixth Street; and Julius and Emma Giammattei (standing, third and fourth from left) operated the Julius Hotel and Italian Restaurant at 303 J Street. (Courtesy Vera L. Whybark Collection.)

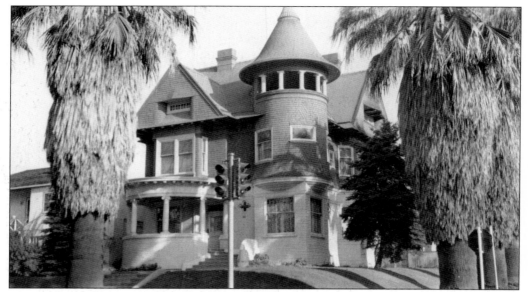

The residence, built *c.* 1900 at Twenty-first and T Streets, was the home of the Mr. and Mrs. Fred Mason of Mason's Steam Laundry and Mason's Haberdashery. The laundry was just across the street and up one block. The late Victorian-style of the residence reflects the social and financial success of its owners. The Queen Anne residence remains today, painted in its original colors of white and brown. (Courtesy Eugene Hepting Collection.)

The residence at 2131 T Street shows the influence of the neoclassical style. This home was built in 1897 by Dr. William F. Wiard. C. E. McLaughlin, a lawyer practicing out of the Forum Building, purchased it in 1907. When this photograph was taken in 1971, it was the Sigma Phi Epsilon fraternity house for Sacramento State University students. It is currently a residence and business. (Courtesy *Sacramento Bee* Collection.)

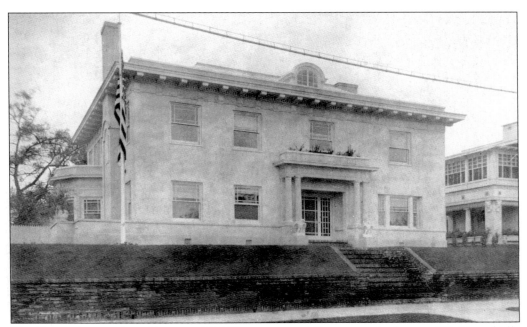

The Beaux Arts–style residence at 2112 Twenty-second Street was the home of C. K. and Ella McClatchy and the childhood home of Eleanor McClatchy. Construction on the residence designed by R. A. Herold began in 1910 and was completed in 1911. The home was donated by the family to the City of Sacramento in 1940 to be used as a library for children. Today it is still a branch of the library. (Courtesy Eleanor McClatchy Collection.)

While president of the *Sacramento Bee*, Eleanor McClatchy resided at 2116 Twenty-first Street. The property included a guest cottage and was located just behind the old McClatchy home on Twenty-second Street. When the home on 2112 Twenty-second Street was donated to the City of Sacramento, Eleanor McClatchy had the backyard added to her property to keep the beautiful gardens she grew up with. (Courtesy Eleanor McClatchy Collection.)

The Italianate residence at 2110 U Street was the home of John Stevens in this c. 1897 photograph. It was built in 1883 for Stevens, then president of Pioneer Box Company and vice president of Friend and Terry Lumber Company. Stevens was the superintendent of streets, and his wife, Eliza, was president of the Sacramento Foundling Home. The house is noted for its rich architectural detail and garden. (Courtesy Eleanor McClatchy Collection.)

Newton Booth was a force in 19th-century business and politics in California. He came to Sacramento from Indiana as a lawyer and ran a very successful wholesale grocery business. His political career included stints as state senator, California governor from 1871 to 1875, and then United States senator. Newton Booth Elementary School at Twenty-sixth and V Streets is a registered landmark that defines the district that has become the Newton Booth Neighborhood Association. (Courtesy City of Sacramento Collection.)

S. Luke Howe's Sutter's Terrace home was at 2201 Twenty-first Street. A successful criminal attorney, Howe was a senior partner in the law firm of Howe, Hibbit, and Johnston, in addition to serving as city attorney from 1902 to 1909. His father and brother ran Howe's Academy and Business College on J Street. This photograph of Howe and his daughter, enjoying the home's landscaping, dates from around 1900. (Courtesy Howe Family Collection.)

This *c.* 1890 photograph of the interior of S. Luke Howe's home at Twenty-first and V Streets shows items that were commonly found in the sitting rooms of Sacramento's well-to-do. Surrounding the fireplace were various paintings and family photographs. A chafing dish sat amidst the table setting, while the upholstered chairs provided a comfortable place for visitors. The extended Howe family lived nearby; Luke's brother, Edward Jr., lived next door at 2215 Twenty-first Street. (Courtesy Howe Family Collection.)

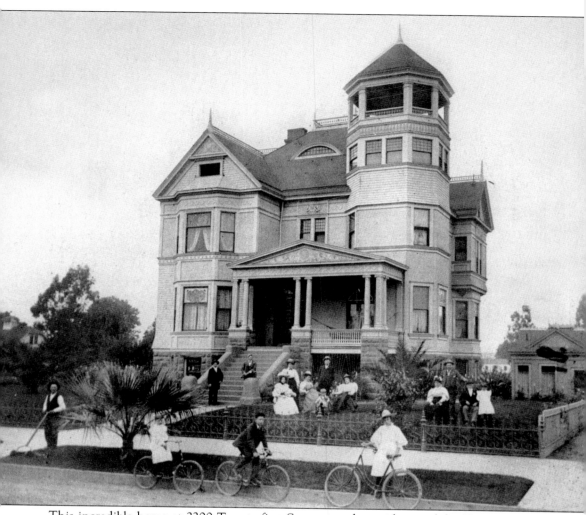

This incredible home at 2200 Twenty-first Street was the residence of the Herman H. Grau family. Its large cupola was typical of the grand homes in the Sutter's Terrace, or Poverty Ridge, neighborhood. Herman H. Grau, a German immigrant by way of Buffalo, New York, was the founder and manager of the Buffalo Brewing Company. An influential Sacramento business, the brewery started in 1888 as a joint stock company. Within a few years, it was shipping its product up and down the Pacific Coast, even as far as South America and China. Grau only had to walk several blocks to the company's plant at Twenty-first and R Street (today the site of the *Sacramento Bee* newspaper). Grau retired from the day-to-day operations in the mid-1890s and passed away at the house on January 11, 1915. This *c.* 1895 photograph shows the Grau family with their three sons and six daughters on the lawn—some on bicycles and another with his lawn mower—in front of the three-story house. Note also the women in the second-story window. (Courtesy Howe Family Collection.)

Beginning their work, from left to right, are Jerome Rogers, Manuel Valdez, and Bill Mathes, preparing to install an anchor to the retaining wall in front of the YMCA at 2021 W Street. The large cornerstone was once part of the old downtown YMCA building at the corner of Fifth and J Streets. The stone was saved when the downtown site was torn down in 1951 and stored until this installation in September 1970. (Courtesy *Sacramento Bee* Collection.)

The Bethel Temple Full Gospel Church was located at 2030 W Street. The dome-shaped wood truss building was part of a campus of structures used by the congregation. Due to the construction of the W-X Freeway, the entire block was leveled in the 1960s. This *c.* 1940 photograph shows a group of children and their adult leaders, part of the church's educational "Banner Class," posing in front of the church. (Courtesy Sacramento Valley Photographic Survey Collection.)

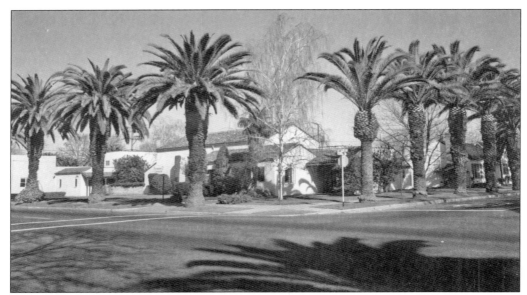

A wonderful example of Mission-style architecture, the Andrews and Greilich Mortuary was located at the northeast corner of Twenty-eighth and W Street. This 1963 photograph was taken before the business was forced to relocate to Fruitridge Road to make way for the W-X Freeway. The destruction throughout Midtown of the block bounded by W and X Streets radically changed the neighborhood, creating an imposing and noisy barrier. (Courtesy Frank Christy Collection.)

During the 1920s, itinerate photographers made the rounds in Sacramento, with goat and cart in tow, photographing children. Wilson H. Jones, on the right in the cart, and his friend, Frank Kassis, pose in front of Jones's house at 2429 Seventeenth Street. Wilson would join his father, Henry Jones, in the freight-hauling business in Sacramento. The business operated for over 40 years, eventually becoming an agent for Allied Van Lines. (Courtesy Wilson H. Jones Collection.)

Seven

TRANSPORTATION
HORSES TO HORSEPOWER
BY CARSON HENDRICKS

Moving people from point A to point B in the Midtown area has been, and still can be, challenging. Many interests had to be considered. Business owners wanted it as simple as possible for their employees and customers to get to their establishments. Local residents, on the other hand, did not want a lot of traffic speeding down streets that were almost exclusively residential. Highway traffic passing through Sacramento also had to be kept moving on surface streets with a minimum of delays. These issues did arise several times in the 20th century, most recently with the traffic-calming project of the late 1990s.

One solution to these problems in the 1960s was the construction of the 29th-30th and the W-X Freeways. While solving the traffic problem, they effectively cut off the Midtown area from the surrounding neighborhoods in East Sacramento, Oak Park, Curtis Park, and Land Park. It eliminated a large number of houses and apartments that were torn down to make room for the freeways. These projects later had the unfortunate side effect of giving Sacramento traffic jams, matching any other city in the country.

As in the downtown area, railroads played a large part in the lives of Midtown residents. The Western Pacific Railroad began service here in 1910, to the great joy of many. While loosening Southern Pacific's monopoly, it was not without problems, some of which are examined in this chapter.

The streetcar system that served a large portion of Sacramento was shut down after World War II and the city went to buses as the most efficient way to move people around the city. However, after 40 years of bus service, a new electric streetcar system, known as Light Rail, began operating in 1986. Light Rail operates along with the bus system, and its ridership has increased each year. Sacramento has had some ingenious and not so ingenious solutions to the problems of transportation. These solutions have always been a balancing act.

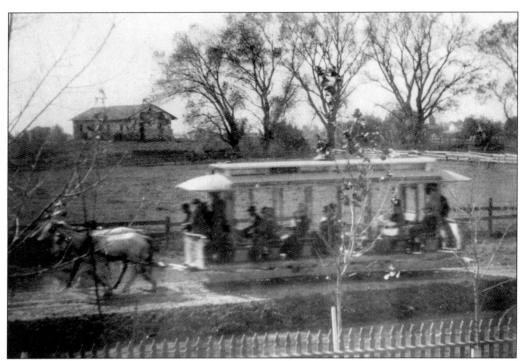

Sacramento's streetcar and trolley system began in 1858 with horse-drawn carriages. In 1861, the system evolved to horse cars on tracks. This grainy image shows such a car passing the remains of Sutter's Fort while traveling up J Street in 1889. The next year, the system began using steam-generated electricity, switching in 1895 to power from the new Folsom Power House. (Courtesy Eugene Hepting Collection.)

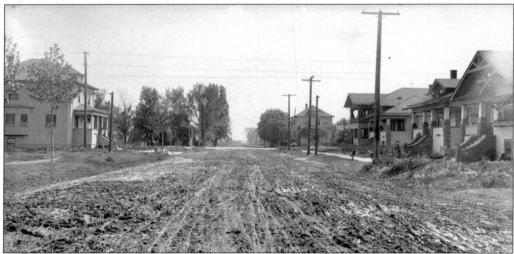

Around the beginning of the 20th century, most Midtown streets looked like this scene. This glass-plate image was possibly taken near the intersection of Twenty-first and M Streets and shows a muddy, rutted street with few improvements. Electric power lines are evident, as are sidewalks on the right. There are no curbs, and the street is unpaved. This c. 1900 photograph shows several Delta-type bungalows. (Courtesy Sacramento Trust for Historic Preservation Collection.)

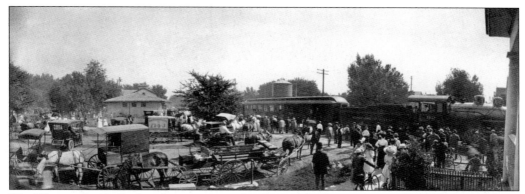

The Western Pacific Railroad station opened with great fanfare on August 22, 1910. As seen here, a crowd estimated to be upwards of 5,000 greeted the arrival of the WPRR at its new station on J Street with speeches from Gov. James Gillett and Mayor M. R. Beard. Southern Pacific strongly opposed the WP operating in Sacramento, prolonging the process over the better part of seven years. (Courtesy California State Library Collection.)

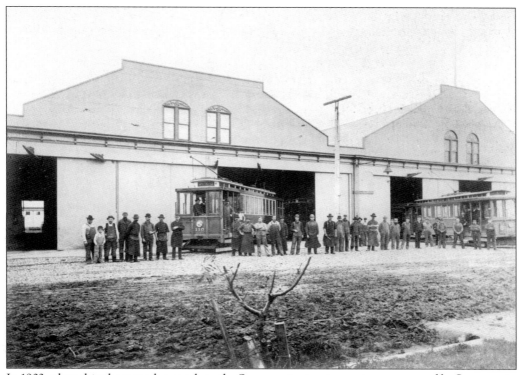

In 1903, when this photograph was taken, the Sacramento streetcar system was owned by Sacramento Electric Power and Light Company. This is the Twenty-eighth Street side of the carbarns, which built 62 new streetcars between 1902 and 1909. Albert Gallatin, the principal founder, left the company in 1904 and was presented with a photograph album by his employees, who held him in the highest regard. (Courtesy William Sommers Collection.)

This photograph, also from the Gallatin album, shows construction of the J Street line at Seventeenth Street around 1903. The street has not yet been paved, but sidewalks and curbs are visible. Building the track system was quite labor intensive and required a large workforce. The streetcar system was dismantled after World War II, only to return in the 1980s as Light Rail. (Courtesy William Sommers Collection.)

This c. 1910 image shows S or T Street at Twenty-third Street being steamrolled after the laying of pavement by the Natomas Company. They used macadam paving, which made the streets drivable year-round. The Natomas Company was one of the largest mining and dredging companies in the world and had ready access to the aggregate needed for this project. (Courtesy Natomas Company Collection.)

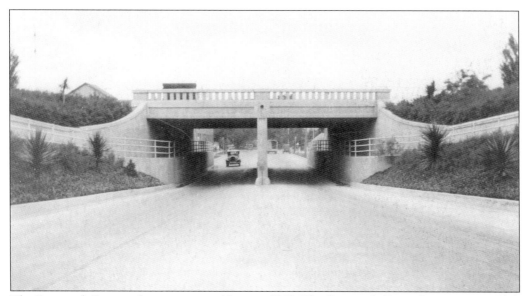

The Sixteenth Street subway is pictured here in 1928. The Sixteenth Street Improvement Club suggested in 1919 that plans and specifications be prepared. The Railroad Commission originally opposed the project, but by 1924, an agreement was reached between the city and Southern Pacific Company for maintenance of the subway. The same structure, somewhat updated, is still in use today. (Courtesy Bob McCabe Collection.)

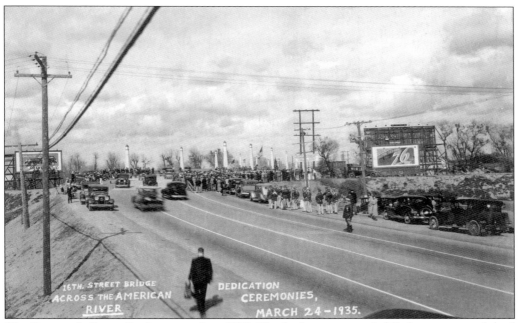

The Sixteenth Street Bridge opened in 1915. The bridge is an earth-filled concrete arch and originally had 10 decorative light poles, which were later removed. The bridge was widened and rededicated in 1935 when this photograph was taken. Because of increased traffic, a second bridge was added in 1968. (Courtesy Charles W. Deterding Jr. Collection.)

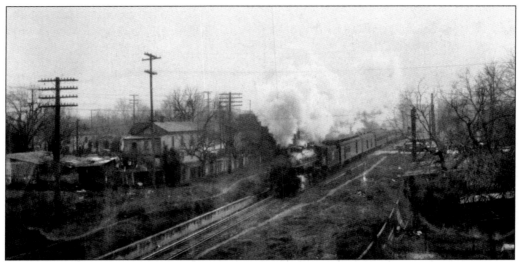

The Western Pacific Railroad, besides running through the center of Midtown, also ran alongside the B Street levee. This image, taken at 2:30 p.m. on January 20, 1939, shows a Western Pacific steam engine pulling a train as it leaves Sacramento. The photograph was taken from the B Street levee looking south. The Western Pacific name ended when the company merged with Union Pacific in 1983. (Courtesy Eugene Hepting Collection.)

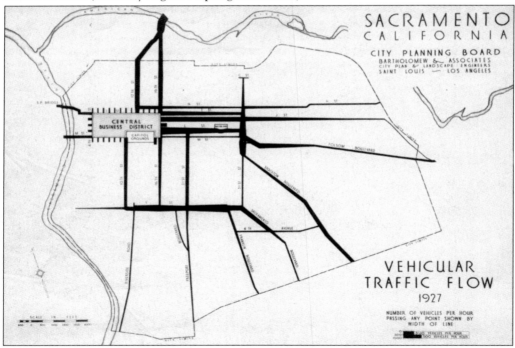

By the mid-1920s, traffic in the city was an issue to be confronted. The 1928 Major Street Report by the city traffic engineer recommended that traffic be distributed to the major arterial streets. The recommendations also called for streets being built to adequate widths to accommodate existing and future traffic. The information for this map was compiled by Boy Scouts counting cars at various intersections. (Courtesy City of Sacramento Collection.)

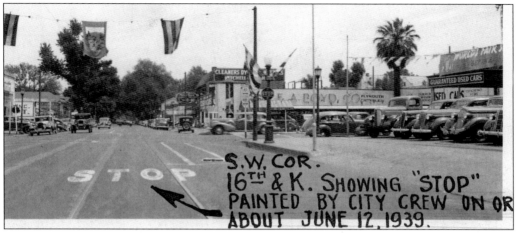

S.W. COR. 16TH & K. SHOWING "STOP" PAINTED BY CITY CREW ON OR ABOUT JUNE 12, 1939.

In 1939, city crews were painting traffic directions on the streets to supplement the signs. Signal lights had not yet been installed at this intersection, but all signs in the city were reflective. Traffic flows had increased dramatically, and by the late 1940s, there was talk of constructing major highways to handle the increase. The intersection seems just as busy then as it is today. (Courtesy Bob McCabe Collection.)

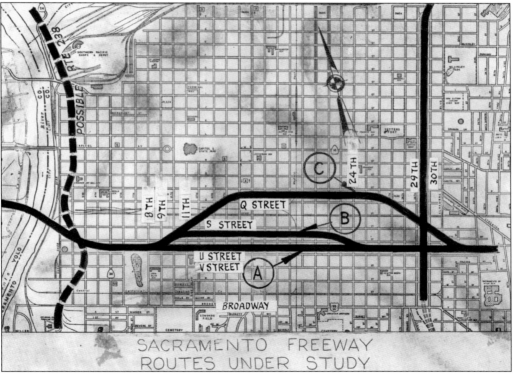

SACRAMENTO FREEWAY ROUTES UNDER STUDY

This map, from the November 21, 1958, *Sacramento Bee*, shows one of the many proposals for freeways in Sacramento. In a report from 1950, there were better than 20 different proposed freeway routes. The route through the middle of town was abandoned, but the other two pictured here were more or less adopted. Just a few short years later, construction of the freeways began. (Courtesy *Sacramento Bee* Collection.)

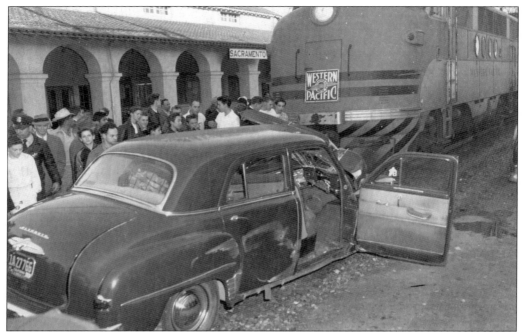

This type of problem still occurs today—people inadvertently making a wrong turn. This 1950s accident between a Plymouth and one of Western Pacific's engines occurred in front of the company's depot (today the Old Spaghetti Factory Restaurant) at Nineteenth and J Streets. Because of the constant changes in traffic controls in Midtown, drivers still have to be vigilant. (Courtesy Eleanor McClatchy Collection.)

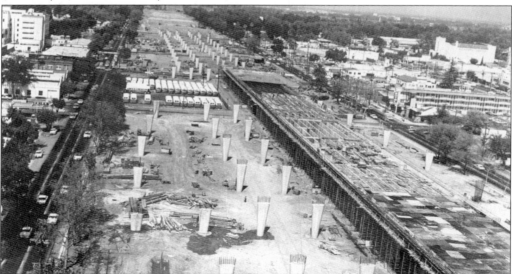

This aerial photograph by Irving Camp shows the 29th-30th Freeway under construction on September 15, 1964. The parking lot for city buses is visible, as is Sutter General Hospital to the left and the Alhambra Theatre to the right. This section connected to the Elvas Freeway that crossed the American River in the distance. This portion of the freeway system cost $6.2 million. (Courtesy *Sacramento Bee* Collection.)

One of the problems associated with the Western Pacific Railroad running through the middle of Midtown was the inevitable traffic jams created when trains passed through or stopped at the station. This incident happened in October 1966 when a broken air line caused the brakes to engage. Ten traffic officers were dispatched to help, and an engine was used to move the train after a 20-minute delay. (Courtesy *Sacramento Bee* Collection.)

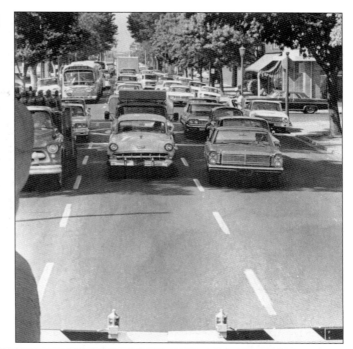

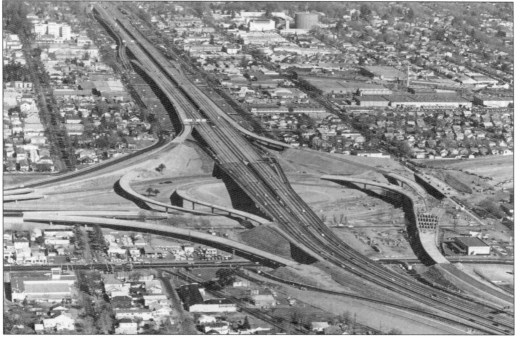

Robert Handsaker took this photograph in January 1968. It shows the completed 29th-30th Freeway and the new interchange connecting it to the soon to be opened W-X Freeway, Highway 99, and Highway 50. This view shows the extent of the project and the swath it cut through Midtown. In 1983, the freeway was renamed Business 80, while the I-880 Bypass was renamed Interstate 80. (Courtesy *Sacramento Bee* Collection.)

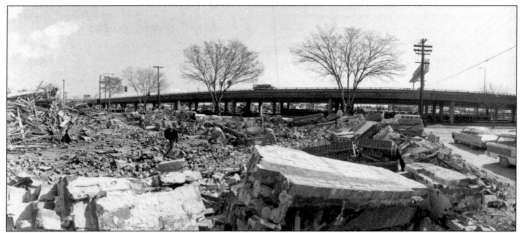

In March 1966, the original carbarn for the streetcar system was torn down to make way for a new facility for city buses. Workers are seen here collecting bricks to be used for other projects. In the background is the recently completed 29th-30th Freeway, then known as Interstate 80. (Courtesy *Sacramento Bee* Collection.)

Another form of transportation being used in the 1980s was roller-skates. Efficient, non-polluting, and quiet because of polyurethane wheels, skates and skateboards became popular among younger residents. Around the turn of the millennium, scooters with the same type of wheels were ubiquitous. Bob Rakela (far left) is in front of the popular Mario's with his family, demonstrating how easy roller-skating can be. (Courtesy *Suttertown News* Collection.)

In 1976, as part of the ever-pressing need to manage traffic in Midtown, the city changed Nineteenth and Twenty-first Streets to one-way streets, south and north respectively. In this April 1, 1976, photograph, John Whitaker of the Traffic Engineering Department is installing the "One Way" sign at the corner of Nineteenth and Broadway. The change was made to lower the number of accidents on Twenty-first Street. (Courtesy *Sacramento Bee* Collection.)

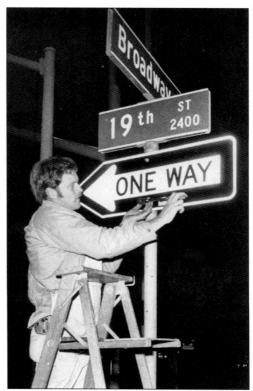

The Sacramento City Council approved the pilot bike-lane marking project in November 1970. The first route went from Sacramento State to the downtown area and back, a distance of 9.1 miles. Bicycles were also popular with the Sacramento Police Department for undercover patrols. According to the description, these three undercover policemen wore "counter-culture clothing as disguises while they patrol the midtown area looking for burglars." (Courtesy Noel LaDue Collection.)

In 1973, the Sacramento Transit Authority changed its name to Regional Transit (RT) to reflect its presence out in the county. On April 1, 1973, Everett White is changing signs touting the new 25¢ fare. Along with the new fare, RT also acquired many new buses and expanded their routes. Courtesy *Sacramento Bee* Collection.)

Opened in 1986, Regional Transit's Light Rail system runs through Midtown on the R Street corridor. The only way to get this system in place was to build an overpass that crossed Nineteenth, Twentieth, and Twenty-first Streets and the right-of-way for the Union Pacific Railroad. Taken not long after the opening, a train is crossing Nineteenth Street next to Superior Lighting Fixtures in 1986. (Courtesy *Suttertown News* Collection.)

Another issue associated with the Western Pacific tracks was the often poor condition of the crossings. This photograph, taken on March 13, 1984, on J Street in front of the WP station, shows just how bad it had become. Crossing the tracks was a bone-jarring, suspension-destroying experience for many motorists. The crossings have since been repaired and upgraded. (Courtesy *Sacramento Bee* Collection.)

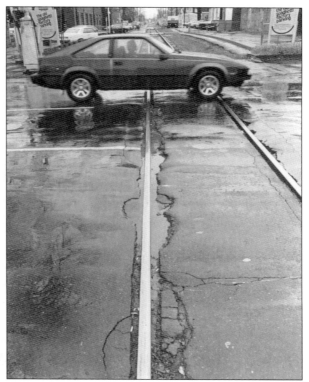

The Sutter Galleria was built around and under Business 80 between J and K Streets and opened in 1987. This was considered a highly ingenuous use of the space. The award-winning design was the first retail space in California to be built under an existing freeway. Until this was constructed, the space was only used for parking, as can be seen in the lower right. (Courtesy *Sacramento Bee* Collection.)

On January 3, 1996, this Nissan Pathfinder SUV was trying to avoid an accident at Twenty-sixth and Q Streets. While that maneuver was successful, the driver then plowed into a nearby house at 1631 Twenty-sixth Street. This illustrates the concern Midtown residents have with motorists speeding through their neighborhoods. Fortunately no one was seriously injured in this accident. (Courtesy *Sacramento Bee* Collection.)

Accidents like the one above led directly to a controversial plan called "traffic calming." In an attempt to slow down traffic and make the area safer for pedestrians, traffic circles, like the first one pictured here at Twenty-sixth and E Streets, and half-street closures were installed. The goal was to move commuters to main arteries such as J and K Streets and off residential streets. (Courtesy *Sacramento Bee* Collection.)

Eight

SOCIAL LIFE
MIDTOWN'S CULTURE
By Patricia J. Johnson

Development east of Sixteenth Street included a mixed use of single-family homes, apartment complexes, and businesses along with cultural venues, schools, churches, hospitals, and parks. Shaped by Sacramentans' need to expand as the city became overcrowded, people began moving eastward into the corridors beyond the capitol. As they moved, residents developed parks in blocks that were set aside when John Sutter Jr. laid out Sacramento. Among these were New Helvetia Park, Winn Park, and Marshall Park. The Union Park Track, in what became Boulevard Park, was home to harness racing and later bicycle racing from 1861 until Park Realty bought the track and subdivided the neighborhood in 1905. Snowflake Park, located at Twenty-eighth and R Streets, was home to Sacramento professional baseball teams, playing there until 1897.

Surrounding Sutter's Fort, the neighborhood established a number of houses of worship and cultural venues that would complement the restored fort. St. Francis Catholic Church, along with the Pioneer Memorial Congregational Church and their Mission Revival–style architecture, were among these. The Tuesday Clubhouse and Scottish Rite Temple provided a cultural and social venue for the neighborhood.

As Sacramentans moved into the East End, schools sprang up; the earliest being Jefferson School and Sacramento Grammar School, both of which were built in the 1870s. Sacramento Grammar School became Mary J. Watson School at Fifteenth and Sixteenth Streets between I and J Streets in 1910. It fell to the wrecking ball in 1925 to make room for the present-day Memorial Auditorium.

Designed by city architect James S. Dean, the Sacramento Memorial Auditorium was built to provide Sacramentans with a large enough venue for concerts, ceremonies, and other cultural events. Opened in 1927, the auditorium was dedicated to those from Sacramento who made "the supreme sacrifice in service to the United States." The auditorium has provided Sacramentans with many memories over the years, whether it was attending a concert or a graduation.

Today Midtown's cultural and social life is well and thriving. The rehabilitated Memorial Auditorium reopened in 1996 after being closed for 10 years. The neighborhood sponsors art walks, film festivals, and farmer's markets. Art galleries, shopping, great restaurants, and entertainment abound in Midtown.

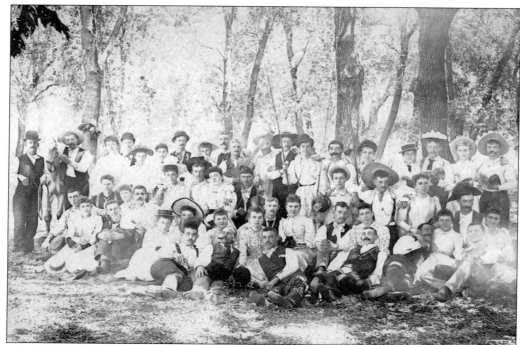

The New Helvetia Park picnic grounds were on the outskirts of Sacramento in 1894. The park was adjacent to the New Helvetia Cemetery at Thirty-first and J Streets, and many families picnicked there. While most of these people are unidentified, note the musicians, dapper dress, fishing poles, and the horse that appear in the photograph. The cemetery was removed in the 1950s to make room for Sutter Junior High School. (Courtesy Miriam Butler Collection.)

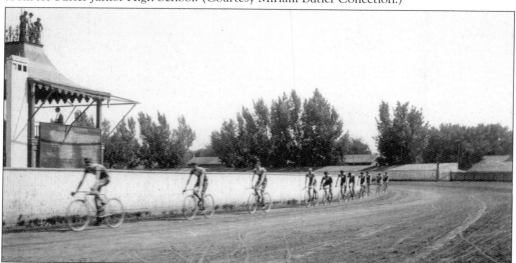

The Union Park Track in Midtown was between Twenty-first, Twenty-second, and B through H Streets from 1861 until subdivided for the Boulevard Park neighborhood in 1905. The state fair sponsored harness racing first. Bicycle and early automobile races were common at the track. The Capital City Wheelmen, a Sacramento bicycle club, participated regularly in the races. The infield of the track hosted various Sacramento baseball teams. (Courtesy James E. Henley Collection.)

The Sacramento Parks and Recreation Department has a long tradition of sponsoring children's programs at all the city playgrounds and clubhouses. At this Midtown neighborhood park on C Street, between Fifteenth and Sixteenth Streets, children are enjoying a St. Patrick's Day celebration with punch and cake. The Muir Park clubhouse was decorated with shamrocks and streamers in this 1940 photograph. (Courtesy City of Sacramento Collection.)

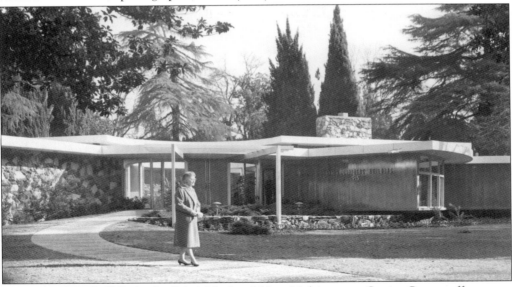

Located in Marshall Park, the Ethel MacLeod Hart Multipurpose Senior Center offers many programs for older adults. Accessible by Sacramento's transit system, the Twenty-eighth and J Streets facility first opened in 1961. Named to honor Mrs. Hart for her generous bequest to the city for the "use, enjoyment, and comfort" of senior citizens, its name was shortened to the Hart Center in 1994. (Courtesy City of Sacramento Collection.)

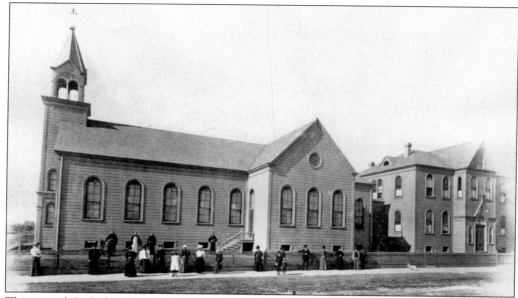

The second Catholic Church in Sacramento, the Franciscan parish began operation in 1894 as St. Francis Church and Monastery at Twenty-sixth and K Streets. St. Francis served the Catholic community in Sacramento for 16 years until 1910, when a new style of church was constructed on the same site. This Midtown church served primarily the German community but was open to all ethnic groups. (Courtesy California State Library Collection.)

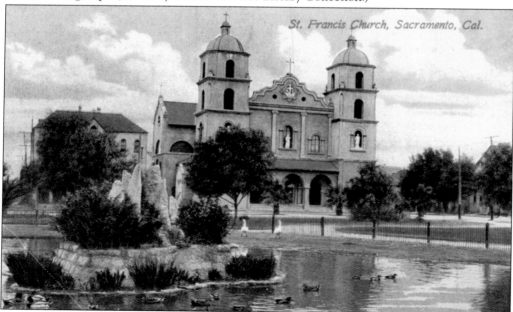

The new Mission Revival–style St. Francis was built at the Twenty-sixth and K Streets site in 1910. Mission churches were popular in California at that time. The construction coincided with the rehabilitation of Sutter's Fort just across the street. Sacramento tourism was in full swing, and the church was just as large an attraction as the fort. This postcard presented an iconic and a romanticized view of California's mission system. (Courtesy Clark A. Barton Collection.)

The new Pioneer Memorial Congregational Church at 2700 L Street was built in 1926 across from Sutter's Fort. It, too, was in the Mission Revival–style and replaced the original church that was founded in 1849 on Sixth between I and J Streets. The church held its services next door at the Tuesday Clubhouse until the building was finished. This 1934 view is from Sutter's Fort. Note the cannon in the foreground. (Courtesy Eugene Hepting Collection.)

By 1920, the small Greek community established their first permanent church in Sacramento. That church, located at 620 N Street, would serve the community until they built their new church in 1951 at Alhambra and F Streets to meet the expanding needs of their congregation. This is a view of the Greek Orthodox Church of the Annunciation under construction. It cost more than $300,000 for the land and buildings. (Courtesy Ralph Shaw Collection.)

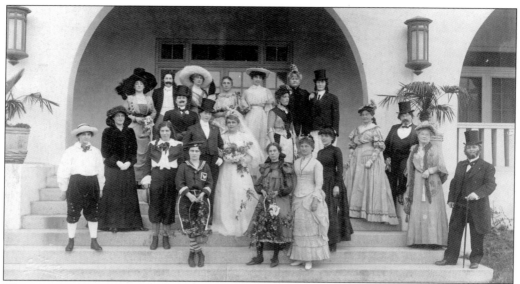

Women wanting to improve their literary, cultural, and intellectual pursuits formed the Tuesday Literary Club of Sacramento in 1896. As the club grew, the women formed the Tuesday Club House Association for the purpose of acquiring land and a building. The building on L Street was completed in 1912. Theatrical productions were a large part of the club's activities, and some cast members are posing on the steps of the clubhouse. (Courtesy Tuesday Club Collection.)

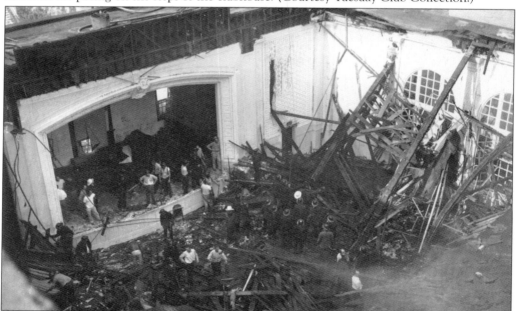

A devastating fire destroyed the Mission Revival–style Tuesday Clubhouse on September 11, 1950. The roof collapsed, injuring fireman E. Carson Hart, who later died of his injuries. The club moved to temporary quarters in the Scottish Rite Temple next door until repairs could be made. Other activities were held in various venues around Sacramento. Taken the day after the fire, this view shows the clubhouse from the roof of the Scottish Rite Temple. (Courtesy Tuesday Club Collection.)

At a cost of more than $100,000, Tuesday Club members voted to rebuild the clubhouse on the same site, bringing it up to modern building-code specifications. Reflecting 1950s architecture, it looked nothing like the original building. In this 1996 view, members and guests are leaving the 100th anniversary celebration fashion show. (Courtesy *Sacramento Bee* Collection.)

Sacramento Bee photographer Randy Pench captured the 100th anniversary festivities inside the Tuesday Club at its L Street location in September 1996. As part of the yearlong celebration, the club hosted a fashion show in its main ballroom. Noted for its promotion of music, art, and literature, the Tuesday Club is still active in Sacramento today. The club has since moved from L Street to the Arden area. (Courtesy *Sacramento Bee* Collection.)

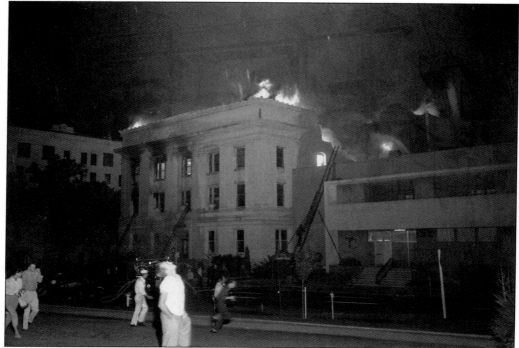

Situated to the east of the Tuesday Club on L Street was the Scottish Rite Temple, the Blue Lodge of the Fraternal Order of Masons. The three-story temple was built in 1917 at a cost of $175,000. A Sacramento landmark, the building was known for its classical architecture and rich interiors. Many Masons took their degrees here over the years. A blaze broke out the evening of October 30, 1958, destroying the structure. (Courtesy *Sacramento Bee* Collection.)

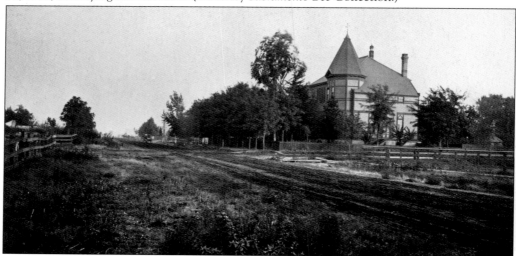

One of Midtown's earliest schools was Primary School, or Fremont Primary School, built in 1881 and named for explorer John C. Fremont. Located at Twenty-fourth and N Streets, this 1889 view of the school shows just how rural this part of the city was in the 19th century. Sarah Mildred Jones became the first African American principal for a fully integrated elementary school, the first in Sacramento. (Courtesy Ralph Shaw Collection.)

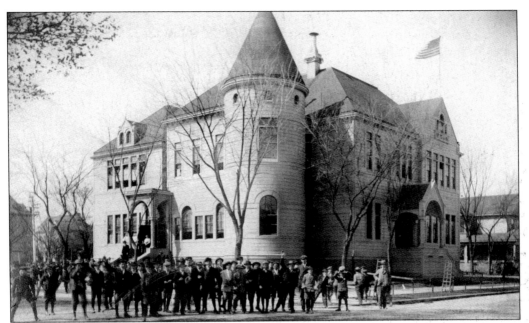

Another of Midtown's early schools was Sutter Grammar School at Twenty-first and L Streets, named for Sacramento's pioneer, John A. Sutter. Built in 1889 at a cost of $15,000, it moved to the Fremont Primary School site in 1922 and served as an administration building for the Sacramento School District until 1950. This 1909 view shows the students in grades six through nine posing for their photograph. (Courtesy Gladys Latham Collection.)

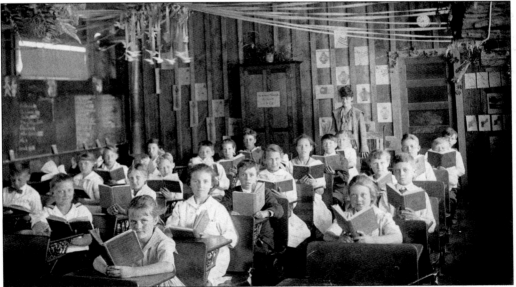

Originally a wood-framed structure, the Newton Booth School at Twenty-sixth and V Streets was later replaced by brick and mortar. Named for a Sacramento businessman and governor of California, this 1917 interior view of a classroom shows students posing with their textbooks. Americare Health Corporation took over the building in 1989, although today it is occupied by Jones and Stokes, an environmental consulting firm. (Courtesy Howe Family Collection.)

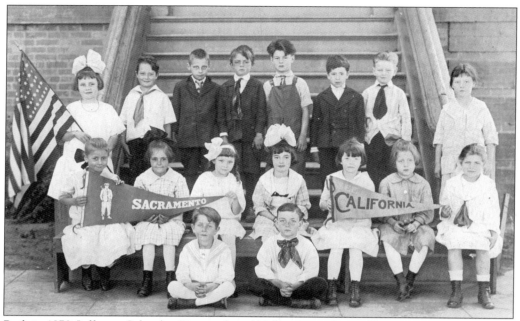

Built in 1870, Jefferson School at Sixteenth and N Streets was burned by arsonists before it could open for the fall term. Rebuilt at a cost of more than $10,000, the school named for Pres. Thomas Jefferson remained in service until 1950, when it became the site for the Sacramento city school administration building. The students of Clara Hoit Fountain pose on the steps of the school in 1917. (Courtesy Phoebe Astill Collection.)

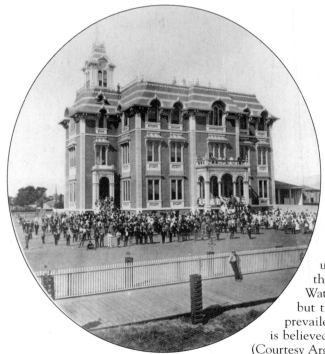

Sacramento Grammar School, as it was first known, was built in 1872 on the site of present-day Memorial Auditorium. Mary J. Watson was elected principal in 1888 and served until 1896. The school district changed the name of the school in 1910 to honor Watson. There was a bit of public protest, but the Sacramento City Commission prevailed and the name stood. This view is believed to be on dedication day in 1872. (Courtesy Argus Books Collection.)

Designed by city architect James S. Dean, the city built Memorial Auditorium on the block bounded by Fifteenth, Sixteenth, I, and J Streets in 1926 to honor all Sacramentans who made the "supreme sacrifice." However the Watson school stood in the way. In need of major repairs, the City of Sacramento decided to demolish the school and use the property for the auditorium. This view from 1925 shows the auditorium from the front entrance. (Courtesy McCurry Company Collection.)

Memorial Auditorium was just what the city needed in terms of meeting space for concerts, ceremonies, and other events. Over the years, schools have held graduation ceremonies, boxing matches have been fought, fraternal organizations have held installations, and even the circus used the auditorium for performances. This exterior view shows the auditorium shortly after it opened in 1927. (Courtesy Sacramento Metropolitan Chamber of Commerce Collection.)

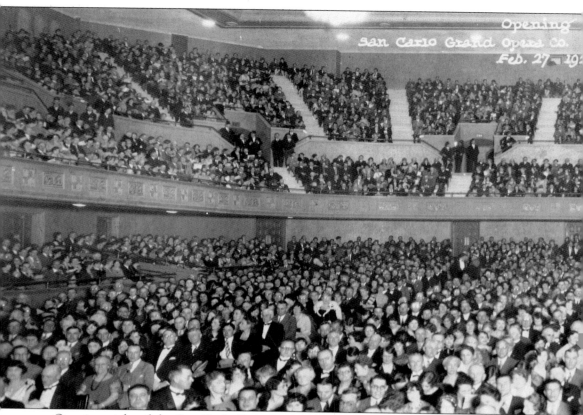

Opening night of the San Carlo Grand Opera Company's performance of *Aida* at Memorial Auditorium was February 27, 1927, just five days after the auditorium had its grand opening on February 22. Conductor Franz Dicks presided over the Sacramento Municipal Symphony

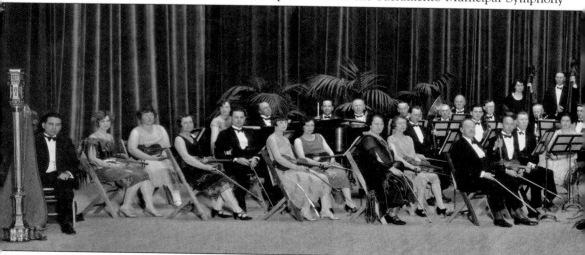

Conductor Franz Dicks is at the podium, and the Sacramento Municipal Symphony Orchestra is on stage at Memorial Auditorium during the grand opening on February 22, 1927. Sacramento dedicated the auditorium with a community program that honored the city's war dead. Patriotic

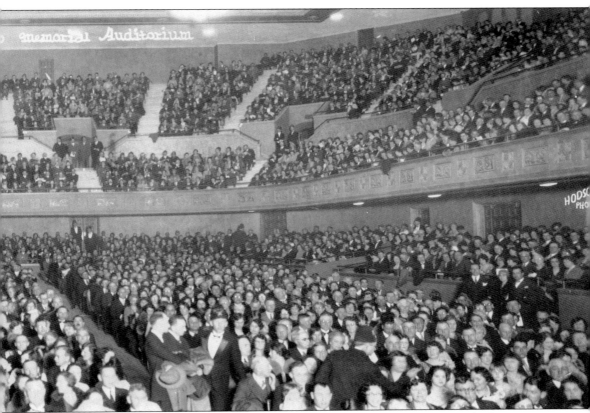

Orchestra in this first noncommunity professional event. This view from the stage looking out over the audience shows the packed house of the 4,600-seat auditorium and how important the venue was to Sacramentans. (Courtesy Franz Dicks Collection.)

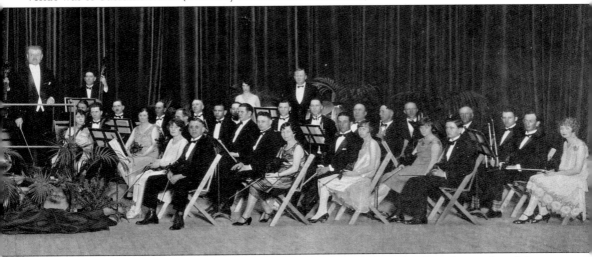

songs and formal remarks by city dignitaries were heard, including the formal transfer of the building to the city. (Courtesy Franz Dicks Collection.)

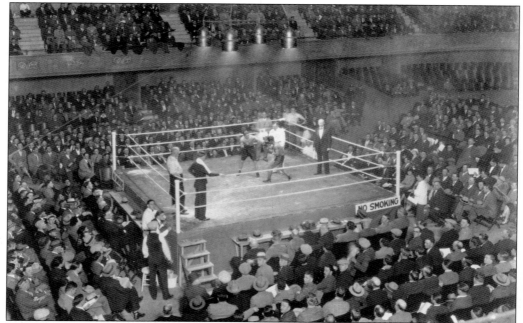

Boxing matches were held throughout the years at the auditorium, and this view is one of the earliest known, probably around 1935. Other sporting events held at the auditorium included wrestling, tennis, and basketball. Even football demonstrations, without an actual game being played, and workshops were hosted there. (Courtesy Bonnie Whele Collection.)

Dance performances at the auditorium were among the events held there. The Art Students League of Sacramento Junior College (Sacramento City College) held an Art Ball each year at the auditorium from the time the auditorium was built through the 1940s. There was a pageant, the crowning of a queen, and a queen's ballet. Each year was a different theme, and the proceeds from the Art Ball went to student scholarships. (Courtesy Mrs. John Matthew Collection.)

Circus performances were another big attraction at Memorial Auditorium. In this view, Ben Ali Shrine-Polack Brothers Circus clown, Lou Jacobs, holds a captivated Christy Huffman (standing) as he makes his way through the crowd. Ticket prices for reserved seats were $2.50 per seat and general admission seats were $1.20. The circus was making its 19th annual appearance in June 1954. *Sacramento Bee* photographer Harlin Smith captured the scene. (Courtesy *Sacramento Bee* Collection.)

Rock icons The Rolling Stones played Memorial Auditorium twice, once in 1964 and again in December 1965. Guitarist Keith Richards was shocked as his electric guitar touched an improperly grounded microphone. The microphone sent a shock that knocked Richards unconscious, and the concert ended after just four songs. This view of Mick Jagger and Keith Richards was just moments before the incident. (Courtesy Joey D Collection.)

ACROSS AMERICA, PEOPLE ARE DISCOVERING SOMETHING WONDERFUL. *THEIR HERITAGE.*

Arcadia Publishing is the leading local history publisher in the United States. With more than 3,000 titles in print and hundreds of new titles released every year, Arcadia has extensive specialized experience chronicling the history of communities and celebrating America's hidden stories, bringing to life the people, places, and events from the past. To discover the history of other communities across the nation, please visit:

www.arcadiapublishing.com

Customized search tools allow you to find regional history books about the town where you grew up, the cities where your friends and family live, the town where your parents met, or even that retirement spot you've been dreaming about.